Published on the occasion of the exhibition *Czech Sculpture: 1867-1937*, at the National Museum of Wales, under the patronage of H.E. The Czechoslovak Ambassador to the Court of St. James's.

D0774971

Published by Trefoil Books
for the National Museum of Wales

Czech Sculpture
1800-1938

Peter Cannon-Brookes

in collaboration with Jiri Kotalik, Petr Hartmann and Václav Procházka

Published by
Trefoil Books Ltd.,
7 Royal Parade,
Dawes Road,
London SW6.

ISBN 0 86294 043 5

Typeset by Words & Pictures Ltd., London SE19
Printed by BAS Printers Limited, Over Wallop,
Hampshire.

Author's Preface

Misinformation and misunderstandings concerning Bohemia have abounded since long before Shakespeare endowed her, in *The Winter's Tale*, with a seashore, and even today mention of Prague immediately evokes a response normally associated with distant, exotic lands. Nevertheless, as was recognised by the Emperor Charles IV in the fourteenth century, he who rules Bohemia effectively controls the cross-roads of Central Europe, and the strategic importance of this beautiful and ancient territory has been the cause of many of the less happy chapters in her history. Today the capital of both Bohemia (the western province of modern Czechoslovakia) and of the Czechoslovak Socialist Republic, Prague is one of the most unspoiled cities of Europe and the growing number of English-speaking visitors attests to its popularity. However this increase in knowledge and understanding of Czech history and Czech culture, and in many fields the lack of literature presents a serious impediment to even the most determined student. This volume is intended to accompany the major exhibition *Czech Sculpture: 1867-1937* which has been organised by the National Museum of Wales in collaboration with the National Gallery in Prague, and it is hoped that it will provide a useful contribution to the further development of Anglo-Czechoslovak cultural relations.

Semantics play an important part in improving the understanding of the English-speaking world and it must be born in mind that in the Czech language (spoken in Bohemia and Moravia) the word 'Czech' means 'Bohemian' and must not be confused with 'Czechoslovak' which applies to the whole republic. Furthermore, the English-speaking world often displays a horror of accented letters in words and consequently a marked reluctance to understand Slavonic proper names. This bias is weakening but, for example, 'r' and 'ř' are two different letters in the Czech alphabet and it is impossible to omit the accents without making the names both unintelligible and unpronouncable. Consequently when a place is well-known from its English equivalent (Prague rather than Praha, or Wenceslas Square rather than Václavské Náměstí) the English equivalent is used throughout the book, but, for example, Malá Strana (literally Small Side) is both untranslatable into an equivalent and incomprehensible when translated literally, and thus the familiar Czech form is retained. In this process it is extremely difficult to be consistent and a very limited knowledge of Prague and Bohemia has been assumed, whilst the intention is that the reader should be able with relative ease to locate in the standard guidebooks places and works mentioned in this book. When a specific location for a work is not given, it is to be found in the National Gallery collection which is today housed in the splendid eighteenth century abbey buildings of Zbraslav a few miles outside Prague.

Without the enthusiastic support of Academician Jiří Kotalík, Director of the National Gallery in Prague, both this book and the exhibition which it accompanies would have been impossible, and

the National Museum of Wales is deeply grateful to it and the Czech Ministry of Culture for the wide-ranging assistance which they have provided. His Excellency the former Ambassador of the Czechoslovak Socialist Republic to the Court of St. James's, Dr. Zdeněk Cerník, and the Chargé d'Affaires, Mr. Zdeněk Vaníček, have been untiring in their support during the last two years, as has Dr. Luboš Travníček of the Ministry of Culture. Her Britannic Majesty's Ambassador in Prague, Mr. John Rich, has been a tower of strength and the National Museum is greatly indebted to him and his Cultural Attachés and their assistants for many services over the last three years, whilst the support of Mr. Richard Alford, Director of the East Europe and North Asia Department of the British Council, and of Mr. Kenneth Pearson, Head of the Visiting Arts Unit of Great Britain has been invaluable.

This book has been prepared by the present author in close collaboration with Professor Dr. Jiří Kotalík, Dr. Petr Hartmann and Dr. Václav Procházka, and they have kindly provided him with an immense amount of information. Much of the detailed work was undertaken in early May 1983 in Prague, but owing to factors beyond the control of the authors the text could not be drafted until August 1983. The present author is particularly indebted to David Maude-Roxeby-Montalto, Duke of Fragneto, for his hospitality and patience in allowing the majority of the book to be written in the Palazzo Ducale at Fragneto, and to his wife Patsy. Certain sections, and in particular the account of František Bílek's career, are almost entirely the work of our Czech collaborators, but although any credit for this volume must be shared, the blame for inaccuracies or misunderstandings falls on the present author alone. Dr. Douglas Bassett, Director of the National Museum of Wales, has extended to this project his unstinting support and it is hoped that both the book and the exhibition will justify the confidence which he has placed in them. Finally, without the skills and enthusiasm of Conway Lloyd Morgan and his colleagues at Trefoil all would have been in vain, and to them a very special word of thanks is due.

Peter Cannon-Brookes
National Museum of Wales
Cardiff
September 1983

*
Unless otherwise stated, all works illustrated are in the collection of the National Gallery, Zbraslav.

Sculpture in Bohemia, circa 1800-1832

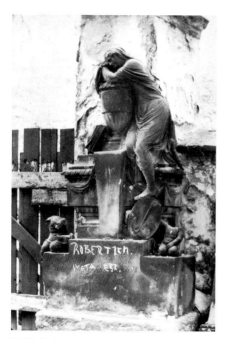

1 F.X. Lederer
Monument to Elizabeth Bertoniova, 1792, stone
Olšanské Cemetery, Prague*

In the course of the latter part of the eighteenth century the strength of the great sculptural tradition established in the first half by Matyas Bernard Braun, Ferdinand Maximilian Brokof and others in Prague was slowly dissipated, and after the 1740s the small centres of sculptural production outside Prague grew stronger at the expense of Prague itself. However, by the end of the century these had virtually disappeared and throughout the nineteenth century and the early twentieth century the overwhelming majority of the better sculpture was produced in Prague for Prague, whilst (excluding Hořice and Bechyně) it was not until after 1920 that sculpture production in Bohemia became more widespread. By the end of the Napoleonic Wars, Prague had been reduced to a minor provincial centre and the outlets for sculpture were accordingly limited – decorative architectural sculpture, tombs, fountains and, to a lesser extent, portraits. Major commissions were not forthcoming, either for Czech sculptors or by way of imports, and those modest productions created around 1800 flowed from the eigthteenth-century family workshops established in Prague. Often on the borderline between the fine arts and the stonemason's craft, much of this stone sculpture, though anonymous, does reveal a deep feeling for the material and an understanding of contemporary stylistic developments in European art, however unostentateously interpreted. Surprisingly little research has been devoted to Czech sculpture of the early nineteenth century and the Czech national collection, housed at Zbraslav, includes relatively few works from this period. Nevertheless these include a number of the most distinguished examples to survive, and the rapid decay of those sculptures still in the Prague cemeteries – under the impact of the twentieth century atmospheric pollution – continues to reduce the survivors still further. Unlike Czech painting of the period, of which we possess a relatively clear picture and where a critical assessment of the individual works and the contributions of the leading artists can be made, the personalities of the sculptors are often shadowy and dated or documented works of significance remain few and far between.

Prague was little touched by the Napoleonic Wars and the reasons for its economic and artistic decline must be sought in the preceding centuries. Czech independence had been lost in 1618, at Bilá Hora (the Battle of the White Mountain when the Imperial forces defeated the Elector Palatine Frederick) and henceforward the Habsburgs ruled Bohemia through the Roman Catholic minority. Immediately after Bilá Hora the Protestant nobility were dispossessed, with many going into exile, and they were replaced by Roman Catholic supporters of the Habsburgs who rarely had any links with the country. The majority of the Czech intelligensia was also Protestant and, like Comenius, sought freedom through emigration. Only a few of the old Czech noble families, which had remained Roman Catholic, survived through to the nineteenth century. Meanwhile, neither Maria Theresa nor Joseph II were crowned as rulers of Bohemia, and the latter removed the last remnants of Bohemian

autonomy. Joseph II's secularisations of church property during the 1780s effectively destroyed the economic strength of the Church and thus its capacity as an artistic patron. This was a particularly serious blow because, in contrast to the heroic period of Czech Baroque art (*c.* 1690-1740) when the nobility vied with each other and the Church as dynamic patrons of the arts, the Church had during the lean decades from 1750 to 1780 provided a continous flow of patronage when the interest of the nobility was switched away from Prague to their country estates. During the nineteenth century the nobility came to their country estates during the summer and spent the rest of their time in Vienna, from where Bohemia was governed: Prague Castle remained virtually deserted.

Ignac František Platzer (1717-1787) had been the leading Czech sculptor of the late eighteenth century, working for Vienna as well as in Bohemia, and his distinctive Later Baroque Classicism owed much more to the example of Georg Raphael Donner than to the Czech sculptors of the generation of Braun and Brokof. At the end of his career he executed the modest monument to the mathematician Josef Steeplinger in the Klementinum in Prague (1781) and this illustrates well the style of productions from the Platzer family workshop at the time that Ignac František's son, Ignac Michal (1757-1826), was preparing to take it over. This workshop remained active until well into the nineteenth century, though it is perhaps best known for the *Ebenberger Monument* in the Malá Strana Cemetery in Prague (*c.* 1800) and Ignac Michal's son, Ignac Johann Karl (1799-1853) in turn became a sculptor. Parallel to the activity of the Platzers was that of František Xaver Lederer and his family workshop in Prague. In the *Monument to Elizabeth Bertoni* in the Olšanské Cemetery in Prague (1792) he had achieved considerable distinction. About 1800 he was responsible for the decorations on the former Irish convent in Prague but he was the last of the line and the Lederer workshop faded away long before that of the Platzers. Lederer remains best known for the much loved *Wimmerova kašna* (1797) of which the original fountain figure is now in the Lapidarium in Prague.

Both I.M. Platzer and F.X. Lederer carried over Late Baroque Classicism into the nineteenth century, but in the sculpture of Josef Malinský (1752-1827) a different spirit is apparent. Born in north-western Bohemia he became a citizen of Prague in 1786 and executed the carved house sign for the House of the Peasants (Domovné znamení U Sedláků) in the Provaznická ulice, Prague, in 1794, and that of the Blue Grapes in the Husová ulice in about 1800. These reveal the freshness and naturalism which are the hallmarks of Malinský's mature style and of the Biedermeyer period. His *Portrait of a Man* (*c.* 1805) on loan from the National Museum to Zbraslav, is amongst the most direct images in Prague art of the beginning of the century, whilst his full-length figure of a *Student*, executed some five years later, displays a curious blend of naivety and sophistication, and almost echoes the music of Schubert.

A generation younger than Platzer, Lederer and Malinský, Václav Prachner (1784-1832) was also the heir to an important family workshop in Prague, established by his grandfather Peter Prachner

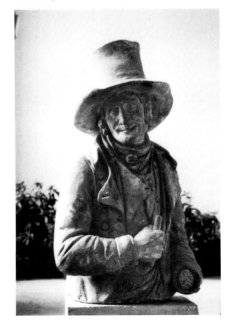

2. Josef Malinský
Portrait of a Man, c. 1805, stone

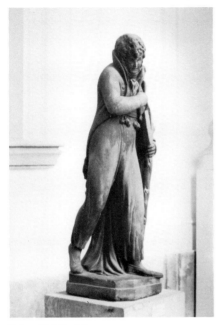

3. Josef Malinský
Student, c. 1810, stone

who had arrived in Prague from Bavaria. However, unlike his older competitors, Václav Prachner was the first significant Prague sculptor to have studied at the Academy of Fine Arts. This had been founded by the Society of Patriotic Friends of Art in 1799 and had opened its doors to students in 1800. The first Director was the painter Josef Bergler (until 1829), and there was no sculpture school as such until 1896, but aspiring sculptors were trained in drawing from the Antique and in 1804 Prachner won a prize for a *Bust of Achilles.* Josef Bergler contributed to the design of the *Monument to Romedius Tomaschek* (1815) in the Olšanské Cemetery, which is probably the finest Neo-Classical monument in Prague, and Prachner's allegorical figure of the *River Vltava* (1812) demonstrates a similarly vigorous approach to Classicism. This elegant fountain figure, formerly alongside the Clam Gallas Palace in Prague and facing the New Town Hall, has been replaced by a copy and the original is preserved at Zbraslav. Compared to his contemporaries, Prachner has a much more sophisticated artistic personality, but the nature of his artistic experience is little known and much detailed research remains to be undertaken. However, in the *Tomb of Bishop Leopold von Thun-Hohenstein* in the Malá Strana Cemetery (1831), which was his last great work, the over-life-size kneeling figure of the bishop has a monumentality and dignity that sets it apart from any other Prague sculpture of the early nineteenth century. Executed in cast iron, not bronze, it was cast by Dominic Zafouk at Hořovice which was a centre for cut steel and cast iron decorative sculpture from the time of the Napoleonic Wars. Iron sculpture of this nature in Bohemia is mostly to be found in the first half of the nineteenth century and the activity of Count Wrtba in the Plzeň area can also be quoted.

The Revival of Czech National Consciousness

Leopold II was the last Habsburg to be crowned King of Bohemia and his action was in great measure calculated as a gesture of reconciliation after the upheavals of the reign of Joseph II rather than to indicate any desire to restore ancient Czech rights. Whereas the Czech language had remained strong during the seventeenth century and much of the eighteenth century, the process of Germanisation accelerated towards the close of the latter. The state language was German, and, as the centralised administration in Vienna was strengthened, the Czech language suffered. Reaction against both centralisation and Germanisation began during the first quarter of the nineteenth century and, inextricably entwined, the political and cultural movements gathered strength during the course of the century. However, for much of the nineteenth century, Prague and the towns were German in language and culture whilst Czech was spoken in the countryside, and the rebirth of Czech national consciousness – beginning with the rebuilding of the Czech language, and then moving into the political and economic fields – consequently

9

has a plebian base. Nevertheless the brilliant flowering of Romantic literature in the Czech language in the mid-nineteenth century achieved an unrivalled mastery of it and Karel Hynek Máche's *Máj* is the key poem of the period. Also of crucial importance was the work of the historian František Palacký whose seminal *History of the Czech Nation* led to his being given the title of 'Father of the Nation'. The first parts were published in German, but then the whole appeared in Czech (1848-76) and made a crucial contribution towards the rebuilding of a Czech national consciousness amongst the better educated. Poet, historian and politician, Palacký saw Czech history in terms of "the constant contact and conflict between the Slavs on the one hand and Rome and the Germans on the other". Consequently, the Hussite Wars which broke out shortly after 1415 became for him the central episode of Czech history and epitomised the national struggle for religious and political freedom. Palacký's influence on his own and succeeding generations was far reaching and did much to fashion the ideas of Tomáš Masaryk and the founders of the First Republic.

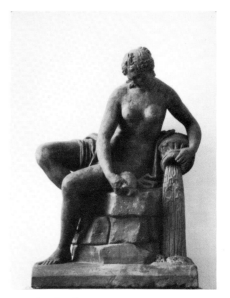

4. Václav Prachner
Vltava, 1812, stone

The Society of Patriotic Friends of Art

Founded in 1796 by a group of interested Bohemian nobles and rich Prague citizens, the Society's patriotism is to be understood in terms of geography rather than nationhood. Consequently in cultural terms it was a Germanic institution for most of its life and did not at first play an important role in the rebirth of Czech national consciousness, although it was responsible for the foundation of the Prague Academy of Fine Arts in 1799 and thus for providing the basic training for generations of Czech artists throughout the nineteenth century. Furthermore the Society soon established its own collection of paintings and sculpture, which constituted the principal public collection in Prague for much of the nineteenth century, and had its own staff of curators. This collection came under state control during the First Republic, with the title of State Collection of Old Art in 1937. Although the Czech National Gallery in effect came into existence in 1945 it was not formally founded until 1949. However, the different histories of the Czech National Gallery and the Czech National Museum are fundamental to any understanding of their different roles in the rebirth of Czech national consciousness and their orientation even today. The Czech National Museum has always had a strong nationalistic role and is fundamentally inward looking within Bohemia, whilst the National Gallery, close in spirit to the ideas of its founding fathers in the Society of Patriotic Friends of Art, is more international in its interests.

5. Václav Prachner
Monument to Romedius Tomaschek (detail),
c. 1815, stone
Olšanské Cemetery, Prague

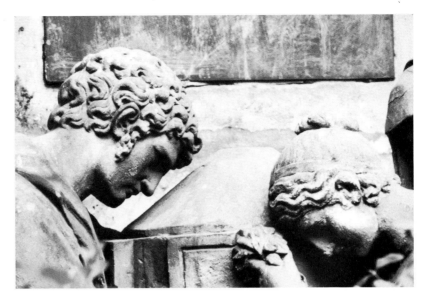

The Foundation of the National Museum in Prague

In the 'Proclamation to Patriotic Friends of Science', dated 15 April 1818, a group of Czech intellectuals headed by Count Kašpar of Šternberk (1761-1838), and including Josef Dobrovský (1753-1829) and František Klebelsberg (1774-1857), announced the foundation of the Museum and, at first, the collections were housed in the refectory of the Minorite monastery attached to Sv. Jakub. After a few years the Museum attracted many of the young Czech intelligentsia, above all František Palacký (1897-1876), and later men of the calibre of Josef Jungmann (1773-1847), the founder of the modern Czech literary language, and Pavel Josef Šafařik (1795-1861), a distinguished poet and leading figure in Slavonic studies, whilst Dobrovský himself was the founder of modern Slavonic studies. The history of this institution, its building at the top of the Václavské náměsti, and its decoration is crucial to an understanding of the development of Czech culture and nationalism during the nineteenth century since the Museum rapidly became a focus for Czech cultural life and national endeavours. 1831 saw the foundation of the Society for the Scientific Teaching of the Czech Language and Literature, based on the Museum, and of its publishing house, Matice Česká, which disseminated its ideas. The involvement of the Museum in the nationalist political movements which culminated in the insurrections of 1848/49 attracted the hostility of the Austrian authorities and from 1850 they held the Museum in anathema. Nevertheless, the broadly based collections, not confined to Bohemia, provided the basis for a vigorous programme of research and publications, and up to the time of the foundations of the Czech University in 1882 and of the Czech Academy of Sciences and Art at the end of the century, the Museum was the leading scientific institution of Bohemia. Less happy was its financial situation and as a private institution, operated

6. J. Kranner and J. and E. Max
Hold Českých Stavů, 1846, stone
Smetanovo nabrezi, Prague

by the Society of the Patriotic Museum in Bohemia, it remained
chronically short of money until 1949 when it became a state
institution and expanded rapidly afterwards.

The Romantic Movement and the Manuscripts of Zelena Hora and Dvůr Králové

Given the intellectual ferment in Czech nationalist circles during the
mid-nineteenth century and the huge popularity of the German
myths exploited by Wagner and others, it was perhaps inevitable that
any presumed inadequacy of the surviving Slavonic myths would be
countered by careful fabrications. There were lessons to be learnt
from the Ossian forgeries, and the long medieval tradition of pious
(and not so pious) forgeries of documents also suggested that there
was always a fair chance of deceiving those who wanted to be
deceived. In the event the richness of the literary material included in
the manuscripts 'discovered' by Václav Hanka at Zelena Hora and
Dvůr Králové made them an immediate popular success and
although Dobrovský remained unconvinced of their authenticity,
their true status as elaborate forgeries was finally demonstrated by
Tomáš Masaryk (1850-1937). Nevertheless a few scholars still believed
in their authenticity as late as the 1930s, though the forensic evidence
published in the 1960s finally laid this 'causus belli' in Czech
intellectual society. Václav Hanka was Keeper of Manuscripts at the
National Museum and thus in a position of unrivalled authority when
it came to the authentication of the discoveries, but the evidence is
now overwhelming that he himself was responsible for their careful
fabrication and that the motives for the forgeries were political rather
than personal gain.

7. Václav Prachner
Tomb of Bishop Leopold von Thun-Hohenstein,
1831, cast iron
Malá Strana Cemetery, Prague

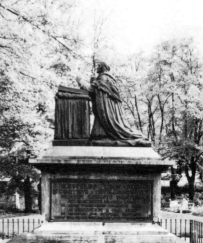

8. Josef Max
Prague Student, 1847, stone
Klementinum, Prague

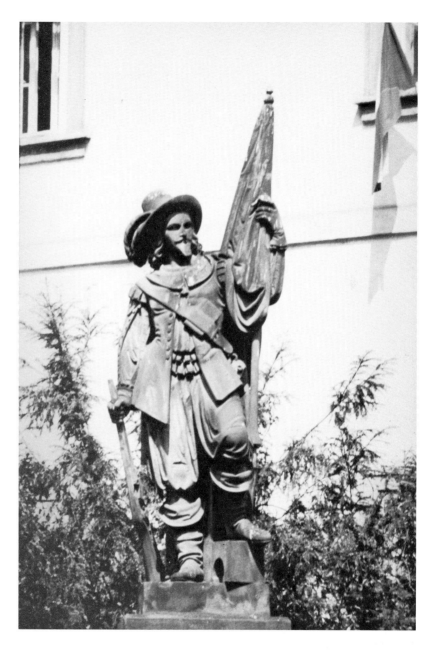

9. Emanuel Max
St. Ludmila, 1849, bronze

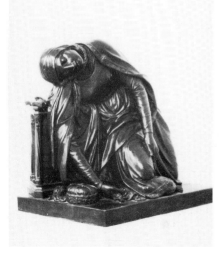

Historicist Romanticism

Completely different in style to Prachner and with no direct
connections with the main Czech sculptural traditions, the work of
the brothers Josef Max (1804-1855) and Emanuel Max (1810-1901)
represents the beginning of a new phase in the evolution of
nineteenth-century Czech sculpture. The Max brothers came from
Slope in Northern Bohemia, their ancestors being stonecutters and
orientated towards Saxony rather than Bohemia. Anton Max (1734-
1808) had been a frame carver for the Kinsky mirror factory, and his
son, Josef Franz (1765-1838), was active there as a sculptor
throughout his life, supplying sculpture to churches at Litoměřice and
elsewhere in the area, but the latter's son, Josef Calesanza, he sent to
be trained in the Prague Academy under Josef Bergler in 1823. In
1830 the young sculptor opened a workshop in Prague for the
production of religious and monumental sculpture, and at the death
of Václav Prachner two years later he was able to take over as the
leading sculptor based in Prague, though his major commissions
were not forthcoming until the1840s. Indeed Josef Max made his
mark with the statue of St. Vitus in Prague Cathedral and the
monument to his brother's teacher, František Tkadlík (both 1840).
Meanwhile, in 1839, Emanuel Max won a scholarship to study in
Rome and, supported by the Emperor Ferdinand V and various
Austrian nobles including the Colloredo-Mansfelds, he remained
there with breaks until the end of 1849, carrying out commissions for
Prague patrons when the opportunity arose. During one of these
breaks Emanuel assisted his elder brother in the execution of the
large number of historical figures on the *Hold Českých stavů* (a
monument to the Emperor Francis I, *ob.* 1835, and Czech history)
designed by Joseph Kranner (1845-47) and erected on the Smetanovo
ňábrezi in Prague. The sharply cut figures owing much to line
engravings as well as German Late Gothic and Early Renaissance
sculpture are entirely alien to the Czech sculptural tradition,
belonging instead firmly to the Germanic world. Only the subject
matter is Bohemian and, apart from the subsequent work of the Max
brothers and Hähnel in Prague, the monument remained isolated in
Bohemia. Josef's *Prague Student* (1847) in the Klementinum,
commemorating the role played by Prague students in defending the
Charles Bridge during the Sack of Prague by the Swedes, is executed
in a more naturalistic style, but again the inspiration is Germanic,
above all due to Ludwig von Schwanthaler.

Modelled in Rome, Emanuel Max's *St. Ludmila* (1849) at Zbraslav
reveals clearly the extent to which he had come under the influence
of the Nazarenes and, executed after the death of Josef in 1855, his
Pietà on the Charles Bridge (1856) is distinguished by its frigid
conservatism. Nevertheless the Max brothers were the ideal choice
for the Austrian government commission for a *Monument to Field
Marshal Radecky*. Although of Bohemian origin, Radecky was very
unpopular in Prague and the monument erected in 1858 in the
Malostranské náměsti was removed for its own safety shortly after
1918 and still remains in store. This is greatly to be regretted since it

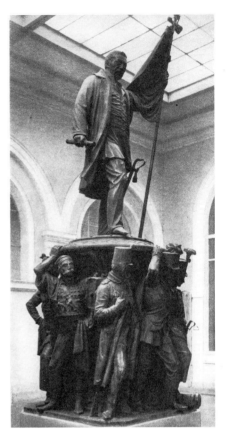

10. J. and E. Max
Monument to Field Marshal Radecky, erected
1858, bronze
Lapidarium, Prague

11. E.J. Hähnel
Charles IV Monument, 1848, bronze
Kriznovicke námesti, Prague

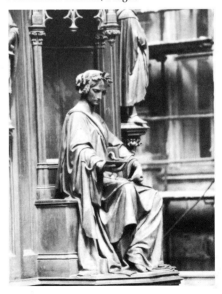

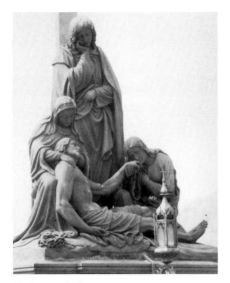

12. Emanuel Max
Pietà, 1856, stone
Charles Bridge, Prague

13. *The National Theatre, Prague*

is much the best product of the Max workshop and the composition, designed by the painter Christian Ruben, of the elderly field marshal carried on a shield supported by eight military figures, looks back to the Brokof groups on the Charles Bridge (in particular that of *St Francis Xavier*). The supporting figures were modelled by Josef immediately before his death in 1855, whilst that of Radecky himself was executed by Emanuel. The latter was a huge success and Emanuel received a number of commissions subsequently for military figures, including the monument to Prince Karl Egon I von Fürstenberg in front of Burg Pürglitz and a series of statues for the Vienna Arsenal.

Equally isolated as the *Hold Českých stavu* , the *Monument to Charles IV*, by Ernst Julius Hähnel (1848) in the Křižovnické náměstí at the end of the Charles Bridge in Prague was ordered from the sculptor in Dresden and for this major monument to one of the giants of Czech history to be imported can be interepreted as a clear reflection of the poor state of sculpture in Prague whilst dominated by the Max brothers. Hähnel (1811-1891) had received a very varied training, including a period with Schwanthaler in Munich in 1830, where he was deeply impressed by Peter Cornelius's frescoes in the Glyptothek, and studies in Florence and Rome, before returning to his native Dresden. Like Emanuel Max, he also was to achieve great success with military monuments, and the Prague monument is of very distinguished quality even if it inspired no imitators. However its lessons did not go entirely unheeded by Emanuel Max and, many years later, Myslbek was to work in Hähnel's atelier in Dresden (1872-73) in order to gain practical experience.

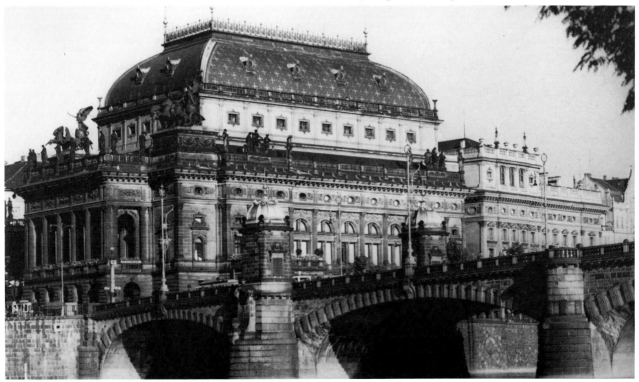

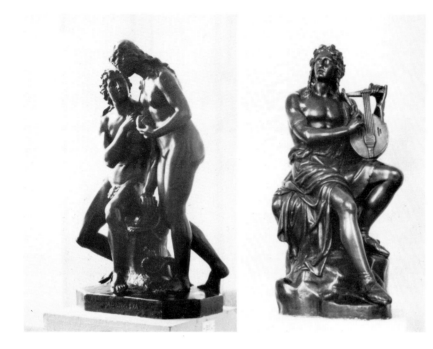

14. Václav Levý
Adam and Eve, 1849, bronze

15. Václav Levý
Lumír, 1848, bronze

16. L. Simek
Monument to Josef Jungmann, 1878
Jungmannovo námesti, Prague

Antonín Veith and Ludwig von Schwanthaler

Included in the decoration of the present building of the National Museum in Prague are the eight life-size bronze figures by Ludwig von Schwanthaler which were commissioned by Baron Antonín Veith (1793 -1853) for his 'Slavín'. A monument to Czech history, and inspired by the Valhalla overlooking the Danube in Bavaria, he planned to build it at Tuplady near Mělnik. Though twenty-four life-size bronze statues were commissioned from Schwanthaler in Munich, by the death of the sculptor in 1848 only eight had been delivered, and when Veith died in 1853 his heirs presented them to the Museum, then housed in the Nostic Palace. At the completion of the present building the eight statues were transferred to it, and four, depicting *Princess Libuše, Přemysl the Ploughman, St. Václav* and *Přemysl Otakar II* were installed in the Entrance Hall, whilst the remaining four, depicting *Eliška Přemyslovna, Jiři of Poděbrady, Arnošt of Pardubice* and *Bohuslav of Lobkovice and Hasištejn,* were set up on the Main Staircase. These Schwanthaler sculptures are of very fine quality and belong to the tradition extending back to the over-life-size bronze figures of the ancestors of the Emperor Maximilian around his tomb in Innsbruck as well as more recent complexes in Bavaria. From 1853 they were easily accessible to all concerned with the revival of interest in Czech history and Czech mythology, but like the monuments executed by the Max brothers and Hähnel their impact on the future development of Czech sculpture was severely limited.

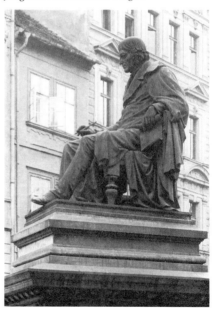

17. National Museum, Prague

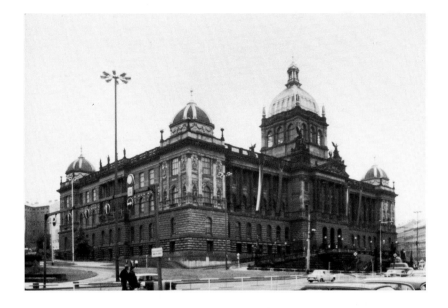

Václav Levý

As a young man Václav Levý (1820-1870) was employed as a cook in the castle of Baron Antonin Veith at Liběcov, but his talents were recognised by the Czech painter Josef Navrátil who was a friend of Veith and was patronised by him. Veith sent Levý to Munich in 1845 to study under Ludwig von Schwanthaler, and in 1850 he returned to Prague. However he could not establish himself there, in the face of the entrenched Max brothers, and in 1854 he left for Rome where he worked until his return in 1866. Levý's figure of *Lumir* (1846), in the Museum of Klatovy, was executed in Munich and like his *Adam and Eve* at Zbraslav (1849) reflects strongly the impact of Schwanthaler's ideas, but his earliest works, the reliefs at Klácelka near Mělník made whilst he was living on Veit's estate at Liběchov, reveal a much more uninhibited response to Czech Romantic literature of the period. *Lumir* is the first significant manifestation in Czech sculpture of the growing strength of Czech national consciousness as expressed through the verses of the legendary singer. In Munich Levý was in contact with the Czech painter Josef Mánes and the impact of his ideas is revealed in the nude figure of *Eve*. Indeed, in its clear sensuality and melodic form Levý foreshadowed the essential qualities of one future line of development of Czech sculpture, but the tragedy was that Levý, after such promising beginnings, turned in Rome to the art of the Nazarenes, by then already a thing of the past. He lost contact with his Czech origins and his later religious sculpture became increasingly cold and sterile, through his relief of *Christ with Mary and Martha* (1858) at Zbraslav is not without quality.

Connected with the art of Václav Levý is the work of one of the younger pupils of the Max brothers – Ludvík Šimek (187-1886) –who

18. Anton Paul Wagner
Music (detail), 1885, stone
Rudolfinum, Prague

spent the years 1864 to 1870 in Rome and worked at first in Levý's atelier there. In Rome he began to model the series of large medallions for the bronze doorway of the Karlin Church in Prague (1864), following the designs of Josef Mánes. However his most important contribution to the nineteenth century Czech sculpture was his *Monument to Josef Jungmann* (1878) in the Jungmannovo náměstí in Prague, executed after his return from Rome. Apart from the impact of Thorwaldsen's sculpture, revealed in the simplified monumentality of the forms, the seated figure of the great scholar of the Czech language immediately invites comparison with the much later *Monument to Goethe* in Vienna by Edmund Hellmer.

19. Anton Paul Wagner
*Bohemia between the River Labe and the River
Vltava,* 1890, stone
Wenceslas Square, Prague

The Building of the National Museum

From Sv. Jakub the collections of the National Museum were
removed to the Šterberk Palace on the Hradčany, and thence to the
Nostic Palace on Na Příkopě, but 1875 saw the demolition of the old
fortifications of Prague, and the removal of the Koňská brána (Horse
Gate) made available the site of the present building. František
Ladislav Rieger (1818-1903) seized the opportunity and the competition
for the design of the new building (1883-84) was won by Josef
Schulz (1840-1917). Construction began in mid-1885 and the
Museum was handed over to the Czech nation at a ceremony held in
the Pantheon 18 May 1891: the collections have been open to the
public on a regular basis since 15 June 1893.

With the installation of the eight Schwanthaler bronze sculptures in
the Entrance Hall and on the Main Staircase, the ideas of Antonín
Veith came to fruition in the National Museum and the core of the
building, above the Entrance Hall, is occupied by the Pantheon.
Intended as a national Slavín, commemorating the outstanding
representatives of Czech cultural life, a list was drawn up at the end
of the century as to who should be included in it. The majority of the
sculptures was executed in the campaign of 1898-1901, but they have
been augmented subsequently, and the six statues and forty-three
busts are the work of twenty-four sculptors and thus comprise a
major museum of Czech portrait sculpture as well as a shrine of
Czech nationalism. Furthermore the iconography of the Pantheon is
carefully planned so that the sculpture is fully integrated with the
wall paintings by Václav Brožík (1851-1901) and František Ženíšek
(1849-1925) – two lunettes each – and the vault by Brožík and
Vojtěch Hynais (1854-1925) executed in 1895-1900. These decorations
are relatively conservative in character and the same conservatism
extended to the sculpture decorating the exterior of the building. In
front of the facade facing the Wenceslas Square the commission for

the figures of *Bohemia* between the *River Labe* and the *River Vltava* was given to the Viennese sculptor, Anton Paul Wagner (1834-1895). Although born in Bohemia and from 1851 a pupil of Josef Max in Prague, Wagner studied at the Vienna Academy under Franz Bauer (1857-64) and worked for the remainder of his life there. In 1885 he had received the commission for the figures of *Music* outside the Rudolfinum in Prague, following his work for the National Theatre (1880-81), and thus his selection for this major location at the top of the Wenceslas Square was not entirely surprising. However, these sculptures were amongst the last major 'imports' before the final consolidation of the new Czech school of sculpture under J.V. Myslbek.

The Decoration of the National Theatre

Together with the National Museum, the National Theatre played a key role in the revival of Czech national consciousness and the place which it came to occupy in the life of Bohemia has no parallel in any other country. The rebuilding of the Czech language was seen to be the preliminary step in the rebuilding of the Czech national identity and, ultimately, Czech self-determination. Consequently the significance of the building and decoration of the national Theatre cannot be overestimated, and they absorbed much of the resources available from the later 1860s. Designed by the Prague architect, Josef Zitek, it was built between 1868 and 1881, but no sooner than it was finished, a fire destroyed the auditorium and ruined most of the decorations. The funds for the rebuilding were collected so quickly that the new auditorium – to the designs of Zitek's collaborator, Josef Schulz – was inauugrated only two years later, and part of the interior decorations was redesigned. Almost every artist of high standing in Bohemia was employed, and whilst the sculptural decorations were carried out by Bohuslav Schnirch, Anton Wagner, J.V. Myslbek and others, the painters included Josef Tulka, Mikoláš Aleš, František Ženíšek, Vojtěch Hynais and Václav Brožík. Consequently this grouping of artists is often known as 'The Generation of the National Theatre'.

 The decoration of the foyer, presided over by Myslbek's full-length bronze figure depicting *Music* (1912), constitutes a cultural Slavin, with busts of leading Czech creative artists and performers, and the cycle of monumental paintings depicting scenes from Smetana's 'My Country' executed by Aleš and Ženíšek. On the exterior of the building, the attic storey of the facade is crowned by two elegant bronze Trigas driven by Victories, modelled by Schnirch in 1910-11 from designs made in 1903-07. whilst Myslbek carved the reclining figures of *Opera* and *Drama* over the subsidiary entrance on the south side of the building (1871-72). Since the initial campaign of decoration, sculptured busts have continued to be added and today the National Theatre, like the Pantheon in the National Museum, constitutes a major treasury of Czech sculpture spanning almost a century and a quarter.

Josef Václav Myslbek (1867-82)

20. J.V. Myslbek

A native of Prague, J.V.Myslbek was born on 20 June 1848 and received his early training as a sculptor in the workshop of Tomáš Seidan (before the end of 1866), working also briefly in the atelier of Václav Levý. However his formal studies were undertaken in the painting class of Josef Trenkwald at the Prague Academy of Fine Arts from 1868 to 1872, and at the end of this period he modelled the full-scale maquettes for the figures of *Opera* and *Drama* decorating the subsidiary doorway of the National Theatre which faces the River Vltava (1871-72). Apart from the self-evident links to Michelangelo's reclining figures in the Medici Chapel, these early sculptures display a wide range of sources and the earlier works of Myslbek are characterised by three principal strands, or stylistic tendencies, which correspond to the main trends in Czech nineteenth century art: Classicism, Romanticism and the Neo-Renaissance. Myslbek emerged as an independent sculptor at a time when the tight control over Bohemia imposed by Vienna after the insurrection of 1848-49 began to be relaxed and the economic and cultural life of the country took on an unprecedented vitality. This reawakened national self confidence found its clearest expression in the arts – to which censorship could not be applied very effectively – and whilst in music the challenge was met by Bedřich Smetana and in painting by Josef Mánes, in sculpture it was Josef Václav Myslbek who best realised these aims.

In the early works of Myslbek the different trends coexisted, as he explored the wide range of stylistic possibilities open to a late nineteenth century sculptor: consequently he can be accused of a certain eclecticism in his work before the late 1880s. As might be expected, Classicism is pronounced in a number of early works, such as the lifesize figure of *Hygeia* (1873-74) commissioned for the Priessnitz Memorial at Jesenik which was modelled by Myslbek immediately after his return from an extended journey in Germany in 1872 to 1873. During the latter he had worked in the studio of Hähnel in Dresden, presumambly to gain practical experience since there is little direct influence of Hähnel detectable in his early works. Equally important for the synthesis achieved in Myslbek's mature style is the strong strand of Romanticism and this is seen well in the early small bronzes of the *Apotheosis of the Manuscript of Dvur Králové* (began 1867 but reworked in 1871), The *Dying Žižka blessing his Country* (1870) and the brooding figure of *Záboj* (1873). Myslbek's response to the Romanticism represented by the Manuscripts and Zeyer's *Vysehrad* was intense and may be compared with Smetana's music and the paintings of Aleš. This enthusiasm is well expressed in the coloured frieze of *The Victory Procession of Záboj and Slavoj* (1875) at Zbraslav, and it was the central group of this relief which Myslbek reworked as one of the momumental groups for the Palacký Bridge in Prague.

The four great groups for the Palacký Bridge are both the culmination of the Romantic tendencies in Myslbek's work and their last expression, though before winning the competition of 1881 Myslbek had, inspired by the writing of Palacký created the

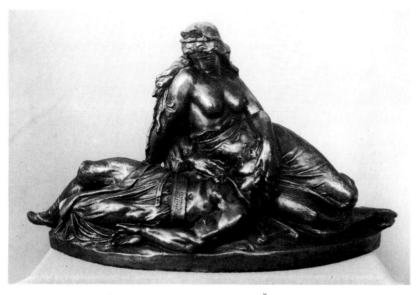

21. J.V. Myslbek
Apotheosis of the Manuscript of Dvůr Kralove,
1867, bronze, 25.5 cm.

immensely powerful Romantic image of *Jan Žižka of Trocnov* at Cáslav, which is one of his early masterpieces. The working up of the models for the groups of *Záboj and Slavoj, Ctirad and Šárka, Libuše and Přemysl* and *Lumir and 'Song'* from the maquettes of 1881-82 took many years and by the time they were set up on the pavilions flanking each end of the Bridge (1892-97) Myslbek's style had developed in other directions. Subsequently removed from the Bridge and set up in the park of Vyšehrad, these monumental groups are imbued with the yearnings and aspirations of their time and constitute the climax of the sculptural ambitions of the National Theatre Generation.

However, in total contrast to the Slavonic fervour of the Palacký Bridge groups, Myslbek was also exploring that other strand which is loosely labelled as Neo-Renaissance. Often merely one aspect of Classicism, the Neo-Renaissance elements are very pronounced in the marble *Tomb of Václav Svagrovský* executed for Roudnice nad abem (1881-83) and now at Zbraslav. The mourning figure draped over the sarcophagus immediately recalls Matyas Bernard Braun's tomb for his mother-in-law, Mrs. Miselius, in the Cemetery at Jaroměř (1723), but none of the Baroque dynamism of Braun is carried over into this cool, poignant treatment of the theme. The wreath slips out of her limp fingers and her head rests on her upper arm, and despite the wilful complexities of the draperies the composition has a remarkable clarity and coherence. Even amongst Myslbek's funerary monuments the *Tomb of Václan Svagrovský* is exceptional – something of a tour-de-force of technical virtuosity – and in the *Tomb of Karel Sladkovski* in the Olsanské Cemetery in Prague (maquette, 1883; tomb, 1884) the figurative elements are considerably simplified. The seated allegorical figure, against the Neo-Renaissance tabernacle, is much more French in spirit – possibly stemming from his visit to the World Exhibition in Paris (1878) – and this is also apparent in the portal figures decorating an appartment block in the Vitežná ulice in Prague which were executed by Myslbek that year.

22. J.V. Myslbek
Drama and *Opera*, 1872, sandstone
National Theatre, Prague

J. V. Myslbek: 'Devotion' and 'Music'

Two key works, *Devotion* and *Music*, provide the high points of the middle years of Myslbek's career and in this period he fully achieved the personal synthesis which he was seeking during his years of eclecticism. In 1880 Myslbek designed a series of allegorical figures for the Vienna Parliament building and from one of these designs he developed his figure of *Devotion* (1884). He took as his basic model Roman statues of Senators dressed in their togas but in reworking the composition he bared the right shoulder of the figure entirely, so that the draperies are greatly simplified and swing across the body in a single unified movement more akin to Donatello's *Prophets* than to their common Classical origins. According to the tradition, Myslbek modelled the head as a likeness of J.E. Purkyně, and this is not unlikely, but in the naturalism tempered by Classical poise and equilibrium and in the directness of *Devotion*, Myslbek established his mature monumental style.

Perhaps the most widely exhibited and successful of Myslbek's compositions of the 1880s is the great bronze *Crucifix* which he modelled in 1885. The original sketch dates from 1877 but in working it up into the over life-size composition he entirely revised it, and the treatment of the hair of Christ and his Crown of Thorns looks towards Art Nouveau. Vast numbers of small reproductions of this crucifix on Bohemian tombs attest to its immense popularity, and a cast is supposed to be in the Sacre Coeur in Paris. The brilliant economy of form and deep poignancy of the full scale version at Zbraslav still come as a surprise, and, with *Devotion*, it consolidated Myslbek's position as the dominant personality in the new school of Czech sculpture.

Only one maquette for *Devotion* survives and thus the evolution of the composition can only be reconstructed in its broad outlines, but for his monumental figure of *Music*, commissioned for the National Theatre, a number of fine preliminary studies survive and its long genesis from 1892 until 1912 can be followed in detail. Seven sketches are preserved in the collection at Zbraslav and they show how Myslbek's two conceptions of the allegory gradually reached maturity. The first is embodied in a fragile, nude figure of a girl by a tree (1892) which evolved into the Symbolist composition, *Swan-Song*, of 1894, whilst the second, which determined the final composition, represents a girl with a harp, partially draped (1892). In the 1894 composition the swirling folds of the pleated draperies reveal Myslbek's early response to Art Nouveau forms and although he himself was not to develop them, figures such as this, and *Thrift* for the Czech Savings Bank (maquette, 1895; full scale marble, 1897), provided the point of departure for certain of his early pupils, including Stanislav Sucharda. The final, over-life-size figure of *Music*, set up in the Foyer of the National Theatre in 1912 is one of Myslbek's masterpieces, and, providing a parallel in sculpture to the compositions of Smetana, it embodies the substance and the character of the Czech national culture.

J.V. Myslbek: Portraits

Myslbek executed portraits throughout his career and their development parallels his evolution as a figurative and monumental sculptor. From the classicising portraits of *Anna Naprstková* (1873, at Zbraslav) and *Pi.M. Wiehl* (marble, 1877), he adopted a much freer, more Romantic treatment for his lively bronze portrait of *K.B. Mádl* (1887). For the latter bust the head and shoulders is supported by a pile of books which provides an additional insight into the intellectual interests of the sitter. For the imposing bronze bust of *František Count Thun-Hohenstein* (1889-91) the portrait is half-length and the expressive hands are supported on a large portfolio held close to the body. Stylistically, this portrait recalls *Devotion* and the restrained economy of the handling serves to emphasise the latent power within the figure, whilst the strong element of controlled naturalism points the way to Czech sculpture of the 1920s. On a more modest scale the same qualities are to be found in the bronze portrait of *Vojtěch Count Kaunic* (1891), but Myslbek's masterpiece in the genre is undoubtedly the over-life-size bronze kneeling figure of *Cardinal Bedřich, Prince Schwarzenberg* (maquette, 1891-92; full scale figure, 1892-95) of which the first cast is in the Ambulatory of Prague Cathedral. For this sculpture Myslbek took as his point of departure the kneeling figure of *Bishop Leopold von Thun-Hohenstein* by Prachner in the Malá Strana Cemetery, though following his visit to Paris in 1878 the impact of Germain Pilon's kneeling figure of *Cardinal René de Birague*, with its similar interest in the fall of heavy draperies, cannot be discounted. With the Schwarzenberg monument Myslbek demonstrated that Vienna was no longer the only centre in the Austrian Empire capable of producing monumental figurative sculpture of European stature, and the changed relationship between the two cities was reflected, in the late 1890s, by a sharp reduction in the number of students of sculpture wishing to pursue their advanced studies in Vienna (or Germany) and instead desiring to broaden their experience by working in Paris.

Close in date to *Cardinal Schwarzenberg*, but less formal and with considerably deeper psychological penetration are the busts of *Bedřich Smetana* (bronze, 1893-94) and *Josef Jiří Kolár* (bronze 1894): with its expressive, broken surfaces the latter looks toward the brilliant later portrait of *Vojtěch Lanna* (bronze 1909). Meanwhile, for the almost three-quarter length portrait of *Josef Hlávka* (bronze, 1901) Myslbek redeveloped the compositional motif of the Thun-Hohenstein portrait with, again, the hands playing a very expressive role. The great full-length bronze portraits, executed for the Pantheon of the National Museum, of *Jiří, Prince Lobkowicz* (maquette, 1905; full-size figure, 1907 but no longer displayed), and of *František Ladislav Rieger* (1913-14) apply to portraiture the lessons learnt in the execution of *Devotion*. Myslbek showed himself here as a true master in the brilliant modelling of contemporary garments, retaining a descriptive naturalism and liveliness of touch without becoming bogged down by anecdotal detail. An enlarged version of the figure of Rieger has been set up in the Rieger Park in Prague.

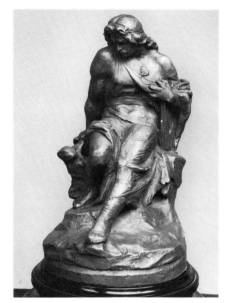

23. J.V. Myslbek
Záboj, 1873, bronze, 35 cm, signed

24. J.V. Myslbek
Hysgieia, 1873-74, plaster

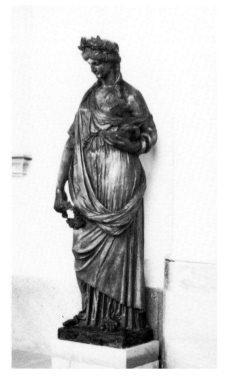

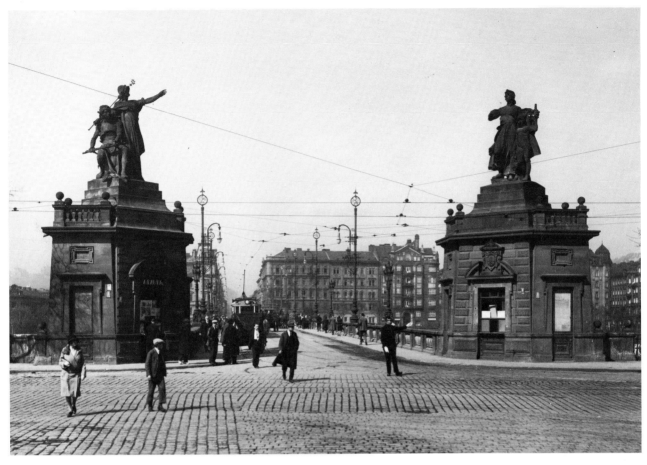

25. General view of the Palacký Bridge, Prague

Early Contemporaries of Myslbek

Best known for his contribution to the decoration of the National Theatre, Bohuslav Schnirch (1845-1901) entered the 1894 competition for the *St.Wenceslas Monument* with a model heavily dependant upon Myslbek. In this the mounted saint is represented as a young prince, bareheaded, whilst the tall pedestal is decorated with such high reliefs that its architectural form is all but submerged. Nothwithstanding its energy there is a certain superficiality about Schnirch's model which presents a strong contrast to the deep seriousness of that of Myslbek. Although Schnirch's equestrian monument to *King Jiři of Poděbrady* (1888-91: set up there) is not unsuccessful he was unable to compete effectively with Myslbek and most of his commissions were for architectural decorative sculpture or minor works. The latter included a number of historical busts for the Pantheon of the National Museum (1901-02). Myslbek did not work on the rather thankless task of creating historical busts for the National Museum and his own *Self-Portrait* (1902-03) was not included in the Pantheon until some years after his death. However Schnirch's most successful period of activity was that before Myslbek consolidated his position

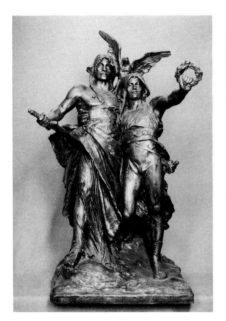

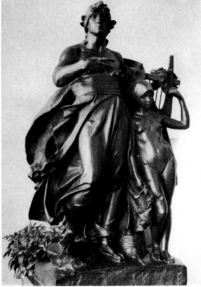

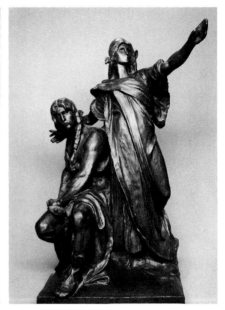

26. J.V. Myslbek
Záboj and Slavoj, 1882, maquette, bronze,
98 cm.

27. J.V. Myslbek
Lumir and 'Song', 1881, bronze, 82 cm.

28. J.V. Myslbek
Libuse and Premysl, 1881, maquette, bronze,
80.5 cm.

and with his death at the relatively early of fifty-six he did not experience the total eclipse suffered by Mauder.

Almost ten years younger than Schnirch, Josef Mauder (1854-1920) also left a considerable mark on the decoration of public buildings and in competitions connected with the rapid growth of Prague during the last decades of the nineteenth century. In his studies for a group on the Palacký Bridge, *Libuše, Přemysl and Lumir* (1881), he was working within the Czech Neo-Renaissance tradition and in his allegorical female figures he stressed the charm and elegance of the body and draperies, sometimes at the expense of pure sculptural values. This is evident in the almost fragile figure of the *Genius of the Nation* (bronze, 1890-92), placing palms on a symbolic sacrophagus, which crowns the Slavin in the Cemetery of Vyšehrad. But from around 1900, Mauder was totally eclipsed by Myslbek and his younger pupils, and consequently neglected for major commissions, but amongst his last works is the remarkable *Monument to Julius Zeyer* in the Chotek Park in Prague (1913). The design of this extraordinary picturesque group of marble figures within a complex of weathered rocks was by this date distinctly passé, but the ideas owe not a little to Šaloun's *Hus Monument*, then nearing completion.

As contemporaries of Myslbek, neither Schnirch nor Mauder were taught by him, but after teaching in the School of Decorative Arts in Prague (1885-1896) Myslbek founded the School of Sculpture at the Academy in 1896 and remained Professor until 1919. At times autocractic and domineering, Myslbek as a teacher exercised very considerable influence but it was: personality clashes which led to Kocián's departure to Hořice and in retrospect it was beneficial for Czech sculpture that the desire of the younger sculptors to escape from the authority of the 'grand old man' encouraged a number to gain experience in Paris, and elsewhere. Nevertheless, apart from the basic training in stone carving available at the School of Sculpture

29. J.V. Myslbek
Záboj and Slavoj, 1892-1895, sandstone
Palachý Bridge, Prague

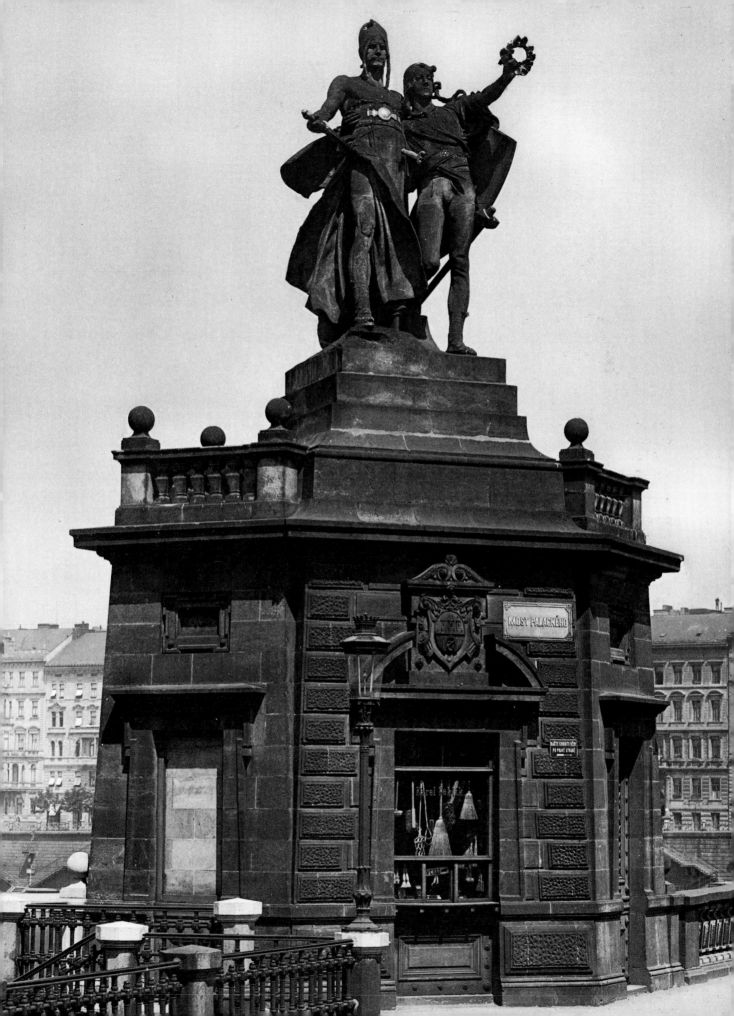

30. J.V. Myslbek
Ctirad and Sarka, bronze, 4.75 cm.

31. J.V. Myslbek
Tomb of Václav Svasrovsky, 1881-83, marble

32. Matyas Bernard Braun
Tombstone of Mrs. Miselius, 1723, sandstone
Jaromer Cemetery

and Stone Carving at Hořice in Eastern Bohemia, and that for terracotta and decorative work at Bechyně, the only training available in Bohemia around 1900 for aspiring sculptors was at the School of Decorative Arts and at the Academy in Prague: hence the very powerful position occupied by Myslbek.

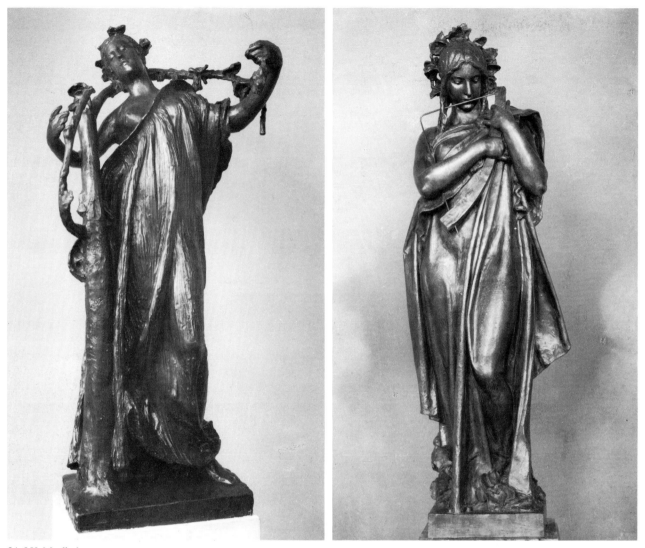

34. J.V. Myslbek
Music, 1892-94, 2nd maquette, bronze,
109 cm.

35. J.V. Myslbek
Music, 1907-12, final version, bronze,
222 cm.

33. J.V. Myslbek
Tomb of Karel Sladkovski, 1884
Olsanske Cemetery, Prague

Czech Art at the Turn of the Century

At the beginning of the last decade of the nineteenth century the range of Czech sculpture appears to be comparatively limited and distinct in style, and the work of the new generation of sculptors – most of them Myslbek's students and then at the beginning of their careers – reflects the variety of styles and individual forms of expression explored by him. This was basically analogous to trends in sculpture elsewhere in Europe, with the exception of Rodin, and it is natural that this new generation soon showed signs of moving away from Myslbek's position. The restless atmosphere of the end of the century was reflected in their striving for new modes of artistic expression, and contemporary developments in the fields of literature and the other arts, particularly painting, played their role. The basic structural changes which took place at the turn of the century affected both the content – for example, note the vastly increased range of subject matter explored – and the form which it took. In Bohemia, then still relatively isolated, the new attitudes crystallized during the course of the last decade into three main aesthetic directions based on different intellectual foundations. During this time Art Nouveau gradually developed from a variety of different sources and marked the last attempt to create a grand unified style which was to leave its mark on all fields of culture. Its accentuated aestheticism, with a stress on the decorative aspects of works of art, had as its counterpart Symbolism, which placed greatest weight on content, often with little regard for the potentialities of form and material. The third direction, artistically the most productive, was Impressionism, which in French art had been the first to mature into a definite style, both in paintng and in sculpture. However, in Bohemia it reached sculpture last, and not until after the Prague exhibition of sculpture by Auguste Rodin, held in 1902. At the risk of serious over-simplification, we could say that the Art Nouveau current is represented in Czech sculpture by the work of Stanislav Sucharda, Ladislav Šaloun, and, to a lesser extent, Quido Kocián, whilst František Bílek is the isolated exponent of the Symbolist trend, and the delayed impact of Impressionism, through Rodin, is above all to be found in the work of Bohumil Kafka and Josef Mařatka. On the other hand Myslbek became an increasingly isolated figure during the last two decades of his life and his *Wenceslas Monument* stands outside the main lines of development of Czech sculpture, though his influence was to reassert itself later in the 1920s.

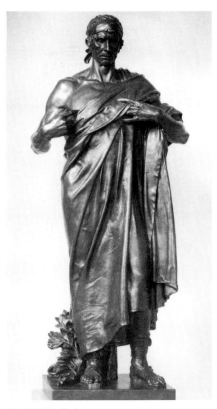

36. J.V. Myslbek
Devotion, 1884, bronze, 246 cm.

37. J.V. Myslbek
Cardinal Bedřich, Prince Schwarzenberg,
1891-95, bronze, life-size
St Vitus Cathedral, Prague

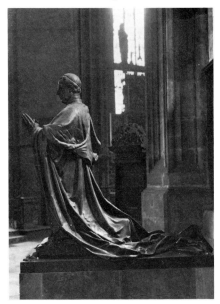

J.V. Myslbek: The Wenceslas Monument

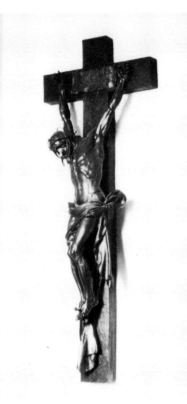

In many respects the final and greatest achievement of Myslbek was the *Wenceslas Monument* which, standing towards the top of the Wenceslas Square in Prague, in front of the main facade of the National Museum, is one of the focal points of the city and occupies a special place in Czech culture and national consciousness. In it Myslbek embodied all his experiences as an artist. Originally conceived in 1887, it occupied him increasingly right up until his death in 1922. The evolution of Myslbek's ideas can be followed in great detail through the maquettes and the rich collection of studio photographs documenting their progress. The earliest maquettes for *St. Wenceslas* (circa 1888) were for a figure in exotic mixed plate and chain mail armour, without any draperies, mounted on a light horse. In the finely finished bronze modello of 1894 at Zbraslav, which won the competition of that year, the Slav armour and strongly Romantic qualities of the earlier maquettes are replaced by standard Western European armour and he wears the Crown of Bohemia. However in the modello and later maquettes of 1895-98 for the principal figure the lighter horse has been replaced by a heavy charger and the figure of *St Wenceslas* is relatively larger, draped and wearing a high cap or a pointed helmet. A studio photograph of the entire layout (1899-1902) documents a further stage in the evolution of the composition when the heavy charger was retained and Myslbek undraped the figure of the saint again. For the definitive composition Myslbek modelled the horse from the cavalry stallion, 'Ardo', which was brought into his studio, and the head of *St Wenceslas* – protected by a high steel helmet with a nose piece, of the Norman type – went through a series of detailed full-scale studies in 1903. The final model was completed in 1904 and cast, in pieces, in 1908. In retrospect it can be seen that in the evolution of *St Wenceslas*, Myslbek moved steadily away from the Romantic Slav vision of the 1880s, of St

38. J.V. Myslbek
Crucifix. 1888-90, bronze

39. J.V. Myslbek
Self-Portrait, 1902-03, bronze, 59 cm, signed with monogram

40. J.V. Myslbek
Bedřich Smetana, 1893-94, bronze, 61 cm. National Theatre, Prague

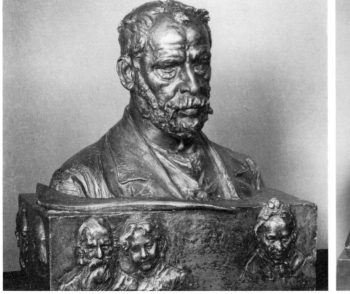

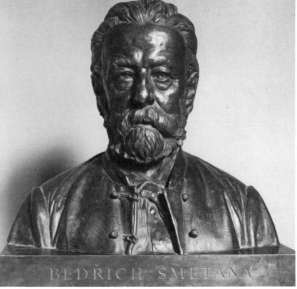

41. J.V. Myslbek
Vojtěch Lanna, 1909, bronze,
72.5 cm.

42. J.V. Myslbek
St. Ivan and the Blessed Agnes,
1898-99, bronze

43. *St Vojtěch and St Ludmila*,
1898-99, bronze

44. J.V. Myslbek
The Wencelas Monument, 1888-1923, bronze,
over-life-size
Wencelas Square, Prague

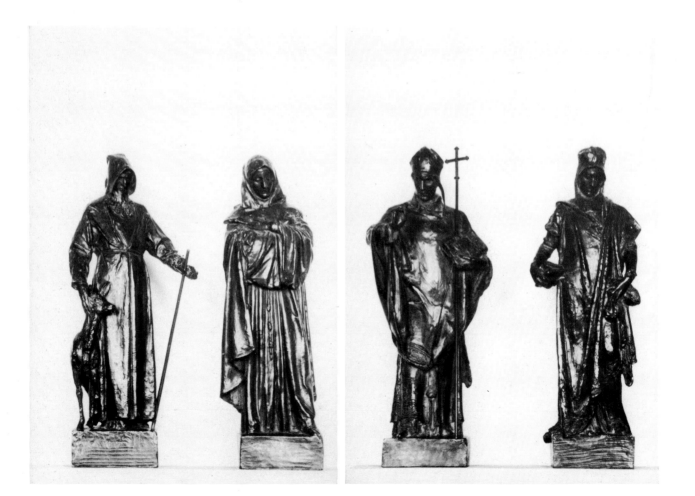

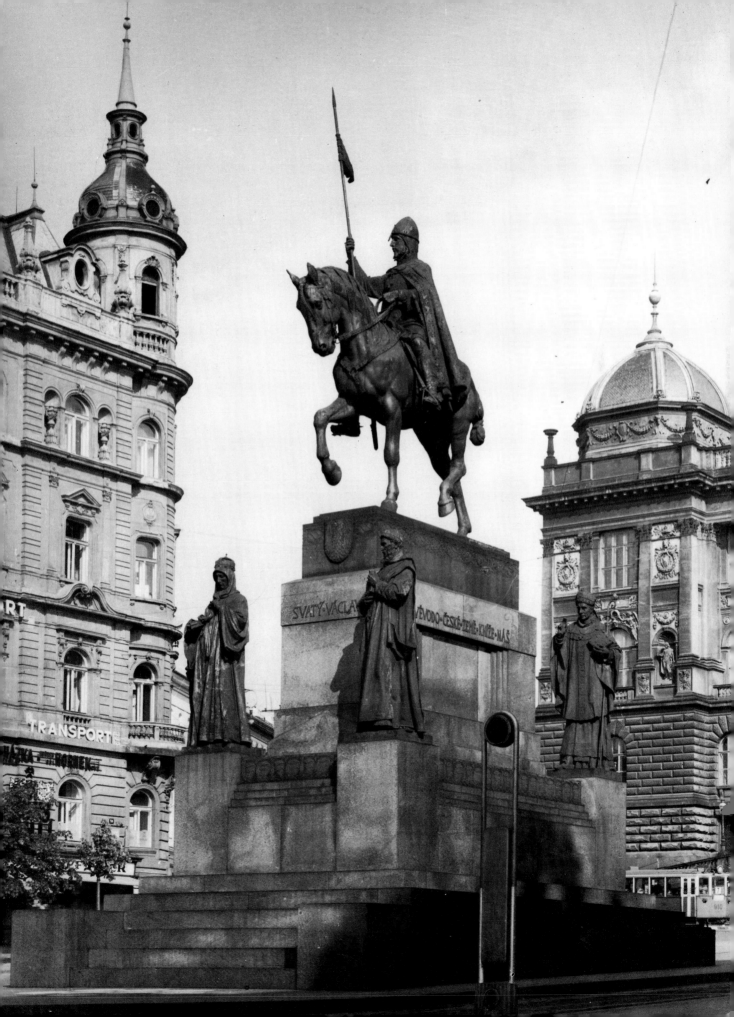

Wenceslas as a spiritual as well as temporal leader, to St Wenceslas as the symbol of the Czech state. Consequently the wild, if Christian, leader of the medieval Slavs is transformed into a modern image of power and authority, and these qualities are greatly enhanced by the classical firmness and compactness of modelling.

The four subsidiary figures around the base of *St Wenceslas* were introduced after the modello of 1894 which was decorated with two long bas-reliefs along its sides, depicting eight patron saints of Bohemia, Vojtěch, John of Nepomuk, Prokop, Sigismund, Norbert, Vitus and Ludmila, and the Blessed Agnes. Myslbek prepared preliminary maquettes in 1895 for full-length figures of Ivan, Ludmila, Vojtěch and Prokop, which he developed further in 1898-99 when he also experimented with that of the Blessed Agnes. In the event the figure of St.Ivan was abandoned and Myslbek instead developed that of Agnes, together with those of St Ludmila and St Prokop, to full-scale models by 1907. These were cast and set up in 1912, but the full-scale model of St. Vojtěch was not ready until 1916 and it was prepared for casting and finished by Myslbek's pupils, in 1924, two years after the sculptor's death.

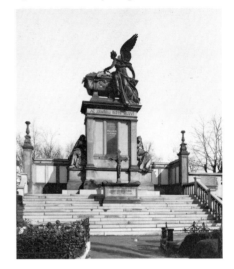

45. Josef Mauder
The Genius of the nation, 1890, bronze, *c.* 3 m. Vyšehrad Cemetery, Prague

Stanislav Sucharda

One of the first pupils of Myslbek at the School of Applied Arts (1886-92), and the oldest of the generation of sculptors after Myslbek to reach maturity, was Stanislav Sucharda (1866-1916) and he made his debut in the Prague artistic scene with the relief *Lullaby* of 1892. The impact of Myslbek's teaching is clearly apparent and the composition has its roots in earlier Czech art – Karel Škreta's *Birth of a Saint* as seen through the drawings of Mánes. Although on this occasion the relief is so high that the figures are almost completely detached from the background, the low relief was to be Sucharda's main field of activity in later years and his major monument – to František Palacký (completed in 1912) – is slightly isolated in his oeuvre. However, the strong element of lyricism evident in *Lullaby* developed into a richly imaginative vision and, far from being a peripheral figure whose work belongs to the sidelines and blind alleys of twentieth century art, Sucharda is in reality one of the great innovators in Czech sculpture around 1900. Passionately interested in all branches of the fine arts, and their interrelations with literature and music, his intellectual character and outlook, together with his ability to formulate theoretical positions, made in inevitable that he would be also active as an organiser and a writer – in the Mánes Union of Creative Artists, in *Free Directions* and on the juries of exhibitions – even if in retrospect it would appear that perhaps too much of his energy was expended on polemics and intellectual squabbles. He had a deep love and knowledge of French sculpture and was instrumental in making it better known in Bohemia, not only in the trend-setting examples of Rodin and Bourdelle, but also the teaching of the medallists A.L. Charpentier, J.O. Rotty and J.C.

46. Stanislav Sucharda in middle age

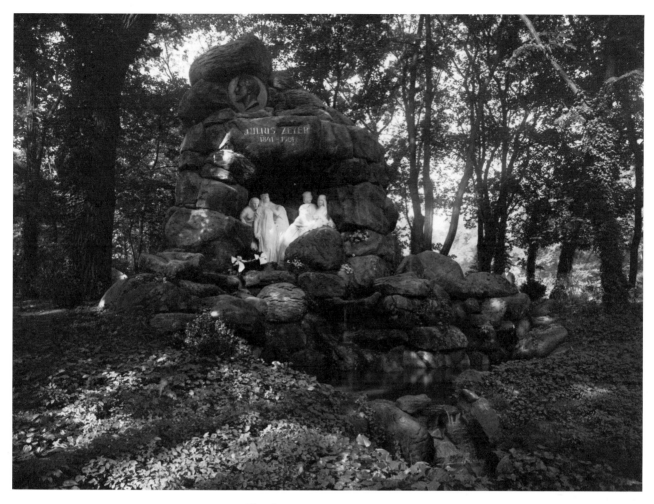

47. Josef Mauder
Monument to Julius Zeyer, 1913, marble and sandstone
Chotek Park, Prague

Chaplain.

The essential character of much of Sucharda's mature work is anticipated by *Lullaby* with its relaxed suppleness and accent on the picturesque which exploits the pattern of light and shade, and tender poetic vision. These qualities, greatly accented, provided the basis for the dream world created by Sucharda in many of his reliefs, and in them he stressed intimacy and a refined sensibility. This subjectivity and poetic approach was seen by Sucharda as fundamental to the new art being evolved in the late 1890s. These qualities are well developed in the cast iron plaquette, *Willow-Tree* (1897), inspired by the ballad of K.J. Erben, and the division into two fields was further exploited in the composition of *Treasure* (bronze, 1898). In the latter the pleated dress, which is treated naturalistically in *Lullaby*, takes on a life almost of its own and its frenetic movement adds an additional dimension to the frantic mother seeking the lost child. Beneath, in the second field, the lost 'treasure' has found treasure and Sucharda exploits to the full the literary ambiguities of the theme. In *Treasure* Sucharda has moved far from Myslbek, but apart from the proto-Art Nouveau elements there are points of contact with both Impressionism, in the modelling of the landscape, and Symbolism, in the treatment

35

48. Stanislav Sucharda
Lullaby, 1892, bronze

of the subject matter. However, by 1901 and the bronze relief of *Libuše forseeing the Fame of Prague*, Sucharda's relief style was in the mainstream of Art Nouveau sculpture.

Parallel with Sucharda's work on small-scale reliefs and plaquettes was his activity as an architectural decorative sculptor and in this field so much depends upon the architect responsible for the overall conception. His earliest work in this field, executed during the 1890s, is undistinguished and tends to be as aridly historicist as the buildings which it decorates. For example, his contributions towards the decoration of the main railway station in Prague, following the overall designs of Josef Fanta (1901-09), are all but swamped by the general confusion of architectural and sculptural forms. All this is in strong contrast to the highly effective partnership forged by Sucharda with the architect Jan Kotěra who had recently returned to Prague after studying in Vienna under Otto Wagner (1899-1900). This is exemplified by the very carefully calculated contrasts between the clear architectural forms and the exotic bronze motif of a broken tree which distinguish the *Tomb of Jakub Vojta Sluk* (1903), in the Olšanské Cemetery in Prague. On a much larger scale, a similar and highly successful partnership of architect and sculptor with Kotěra again is achieved in the former Provincial House (Okresní Dům) at Hradec Králové (1903-04). Sucharda was subsequently responsible for the sculptural decoration of Kotěra's Town Museum at Hradec Králové (1909-12) but by this date the Art Nouveau elements have been totally displaced.

During the decade to 1910 Sucharda developed an increasingly sophisticated relief style in his small plaquettes such as *Spring* (1904) and the pendants *Forest* and *South* (both 1906). In these the very soft, evocative modelling creates a mood of deep nostalgia whilst in others, including *Awakener* (1906), delicate play is made between the softly modelled, almost abstract figurative forms and the bold lettering of the inscription. In contrast, in *Education I* (1909) Sucharda

49. Stanislav Sucharda
Willow-Tree, 1897, cast iron,
60.5 x 16.5 cm.
The work was inspired by K.J. Erben's
ballad

50. Stanislav Sucharda
Treasure, 1898, bronze,
76 x 40 cm (main panel)

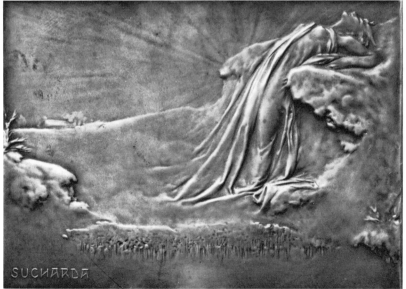

51. Stanislav Sucharda
Libuše foreseeing the Fame of Prague, 1901,
bronze, 49 x 74.5 cm, signed

52. Stanislav Sucharda
Spring, 1904, in electro-deposited copper,
6.5 x 9.2 cm, signed

53. Stanislav Sucharda
South, 1906, copper, 10 x 4.5 cm, signed

54. Stanislav Sucharda
Forest, 1906, copper, 10 x 4.2 cm, signed

55. Stanislav Sucharda
Fairy Tale of the Beautiful Liliana, 1909,
electro-deposited copper, plaquette no III,
9.9 x 10.4 cm

applies this soft tonal handling to a genre scene which almost recalls the spirit of his early *Lullaby*, though on a tiny scale.

However, the high point of this sequence of plaquettes and medals is undoubtedly the series illustrating *The Fairy Tale of the Beautiful Liliana* (1909). In the cycle, originally made as an experimental series of sculptural illustrations, for the VIII Annual of *Free Directions*, and produced by electrodeposited copper, the figurative scenes are reduced to four and the remaining three plaquettes depict a fairy-tale castle on a rock, the richly decorative silhouette of a tree against a distant landscape and a pure painterly vision of the earth and clouds. Ideas known intimately from the traditions of Czech literature and music are here reinterpreted by a sophisticated morphology of Impressionism, Symbolism and, above all, Art Nouveau. Mysterious light, lyrical fantasy, and an exquisite sense of decorative unity combine to make *The Fairy Tale of the Beautiful Liliana* one of the most remarkable creations of Czech sculpture of the decade.

56. Stanislav Sucharda
Fairy Tale of the Beautiful Liliana, 1909,
electro-deposited copper, plaquette no I,
10 x 10.5 cm

The Palacký Monument

Notwithstanding the brilliant innovations of Sucharda in his reliefs
and plaquettes, his crowning achievement is undoubtedly the
Monument to František Palacký. His first design, dating from 1898 and
prepared for the competition, is fragmented and tries to say too
much, but in the design of 1901, which became the starting point for
further work, he was able to balance more effectively the central
figure of the historian and the allegorical figures. After a period of
concentrated effort and intensive studies, in 1906-7, Sucharda
completed the large model, but the scaling up of the elements and
their modelling was a long drawn-out process and the completed
monument was not unveiled until 1912. All too often, by the time a
major sculptured monument is unveiled, the style of the sculptor has
developed far beyond that of the monument, and, indeed, it may
already appear rather old-fashioned. The *Palacký Monument* suffered
this fate and by 1912 it already seemed out of step with
contemporary developments. Consequently neither its high quality
nor its significance have been recognised fully, and this in turn has
unjustly clouded the critical assessment of Sucharda's importance in
the development of Czech sculpture. From every viewpoint the
Palacký Monument is a remarkable achievement and both the bold
synthesis of the ideas and the eloquence of the symbols by which
they are expressed are never reduced to mere empty bombast. The
composition skilfully exploits the different materials employed: stone

for the real world – the monumental seated figure of the historian and the architectonic mass of the monument – and bronze for the world of the imagination – the twisting and soaring allegorical figures. This evocative differentiation of materials was greatly exploited in Art Nouveau sculpture, but by 1912 much of its impact would have been lost and any lack of appreciation and understanding for the monument's rich picturesque qualities and poetic romance is perhaps understandable. The years of effort expended by Sucharda on this huge task severely curtailed his other work and in the eyes of the public his name was only associated with the *Palacký Monument*, though in his small-scale sculptures his style continued to develop,

57. Stanislav Sucharda
Decoration on the facade of the Municipal Museum at Hradec Králové, 1909-12

58. Stanislav Sucharda
Main Entrance of the Okresní Dům, Hradec Králové, 1903-04. The architect was Jan Kotěra

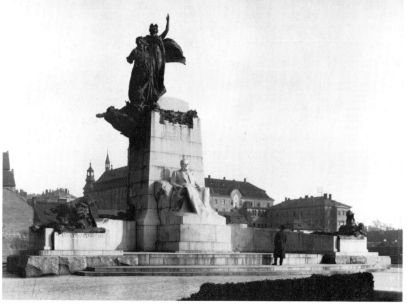

59. Stanislav Sucharda
The Palacký Monument, Prague, 1898-1912

60. Stanislav Sucharda
Figure study for the Palacký Monument, c. 1905, bronze, 25 cm

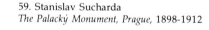

62. Stanislav Sucharda
The Palacký Monument, group with figure of Fame

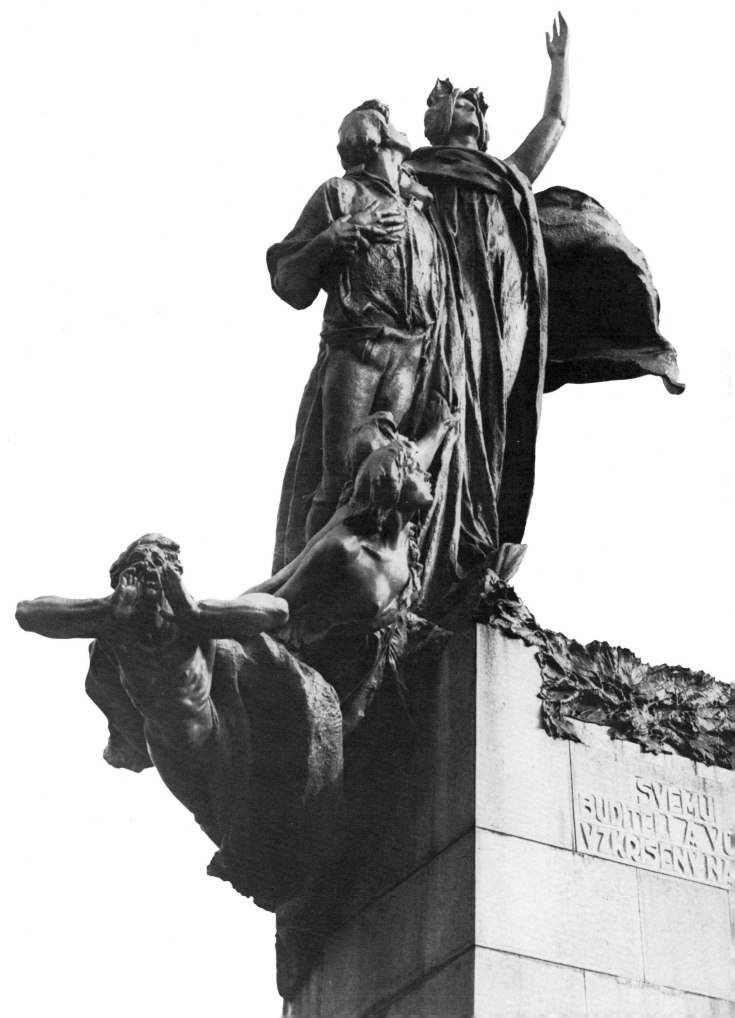

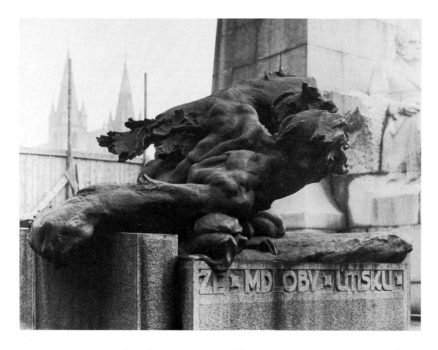

62. Stanislav Sucharda
The Palacký Monument, detail

becoming more sober in expression, His portraits, such as those of
Mrs. M. Slavíčková (1910) and *Vlasta Zindlova* (1911), reveal a sharp
psychological insight and clear sense of structure, but they remain
few and far between and at Sucharda's early death in 1916, aged fifty,
he was still at the height of his creative powers.

Ladislav Jan Šaloun

63. Ladislav Jan Šaloun
Rabbi Low ben Bezálel, 1910, sandstone, life
size
New Town Hall, Prague

If the sculpture of Sucharda has suffered from a certain critical neglect, that of Ladislav Jan Šaloun (1880-1946) has been condemned to be virtually ignored and the huge *Monument to Jan Hus* (1900-15) in the Staroměstské náměsti (Old Town Square) in Prague is still something of an embarassment to art historians and critics alike. A maverick figure in the development of Czech sculpture, Šaloun did not receive formal training in either the School of Decorative Arts or the Academy; obtaining instead *ad hoc* practical training in the studios of Tomáš Seidan and Bohuslav Schnirch. Thus he developed his talents outside the framework of Myslbek's teaching and untouched by his influence. Consequently he did not accept the rigorous tectonic principles which had been instilled into Myslbek's pupils and encouraged them to resist the more extreme forms of Art Nouveau. After some years of work in the historicist tradition – including the execution of decorative sculpture for the Museum Hlavního Města Prahy (Town Museum of Prague, 1895-98) – newly built to the designs of Antonín Wiehl and Antonín Balšánek, Šaloun rapidly came to terms with a wide range of unconventional sculptural expression drawing upon very varied sources of inspiration. From the beginning he was extremely prolific and his exceptional facility in almost every field of sculptural production led on occasion to a certain superficiality, for which he has been over-criticised. However, throughout his work, there is a strong element of naturalism and he was amongst the first Czech sculptors to be interested in social realism, possibly under the influence of Constantin Meunier. In *The Banished* (1900) the sober subject is greatly elivened by the vitality of the surface handling, and these qualities are particularly well developed in the enchanting small bronze *Wild Poppies* (1905). Close in date is the bronze head *Concentration* (*circa* 1905) with its distant echoes of Daumier as well as Rodin, but although Šaloun's interest in the play of light across the surfaces of his bronzes, rather than concern for the structure beneath, is akin to Rodin and was probably reinforced by Rodin's exhibition in Prague in 1902, the use he made of it belongs to the world of Art Nouveau.

Šaloun tackled with relish the large scale commissions for decorative architectural sculpture which were offered to him during the first decade of the century, not least for the decoration of the Obečni Dům (Municipal House) in Prague: the most important late Sezession building in Prague, and virtually unaltered today. The plans for the Obečni Dům, by Osvald Polivka and Antonín Balšánek, were drawn up in 1903 and the massive building was erected in 1905-11. Šaloun was responsible for the large allegorical groups – representing *The Degradation* and *The Resurrection of the People* – flanking the main facade mosaic, whilst the remainder of the rich sculptural decoration of the facade was undertaken by a team of sculptors including Josef Mařatka and František Úprka. Inside, the principal rooms, including the cafe and restaurant on the ground floor, are lavishly decorated with painted and modelled elements by most of the leading Czech artists of the early twentieth century,

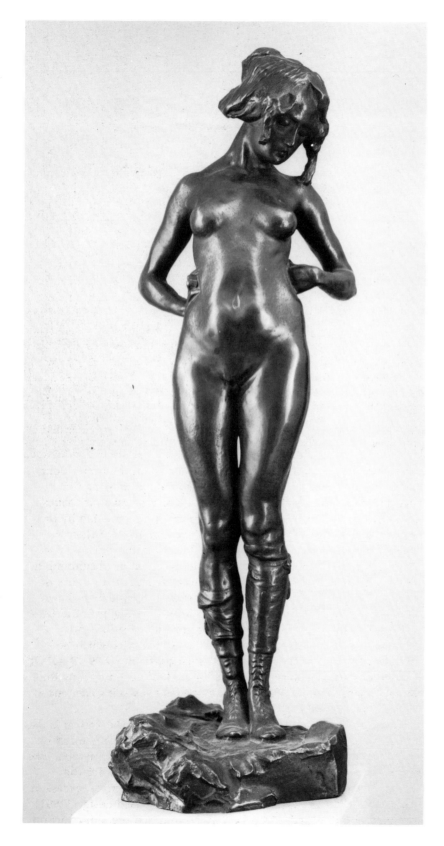

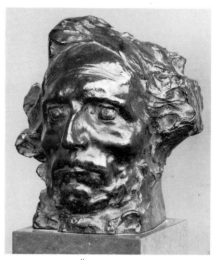

64. Ladislav Jan Šaloun
Concentration, c. 1905, bronze, 30 cm, signed

65. Ladislav Jan Šaloun
Wild Poppies, 1905, bronze, 56 cm

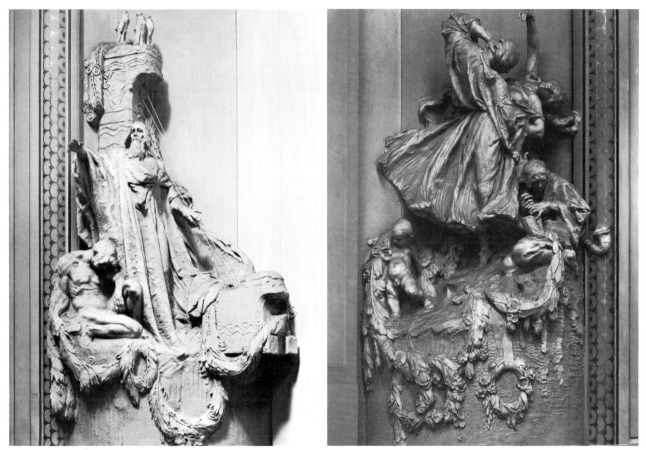

66. Ladislav Jan Šaloun
Vyšehrad, 1907, stucco

67. Ladislav Jan Šaloun
Slavonic Dances, 1907, stucco, over life-size

This group and no. 66 form part of the decoration for the Smetana Hall, Obecní Dům, Prague

whilst the decoration of the great Smetana Hall on the upper floor revolves around the flamboyant groups by Šaloun flanking the proscenium arch. Executed in stucco and depicting *Slavonic Dances* and *Vyšehrad* (1907) these tours-de-force are complemented by the wall paintings of Karel Špillar. The positive qualities of Šaloun's bravura handling of stucco, his love of the exotic and the irrepressible spontaneity of his compositions are at last beginning to be recognised again, and his splendid over-life-size stone figure of *Rabbi Löw ben Berzálel* (1910) in the corner niche of the New Town Hall in Prague is no longer to be dismissed as merely eccentric. Less well known, but nevertheless revealing great imagination and occasional flashes of deep insight, are the six portraits which he modelled for the Pantheon of the National Museum (1899-1914). Of these, the head of *Svatopluk Čech* (1908) evokes most movingly the personality of the poet-prophet and provides a revealing contrast to the later monument by Jan Štursa.

However, the great complex by which Šaloun is best known is the *Monument to Jan Hus* which dominates the Staroměstské náměsti in Prague and is today regrettably little appreciated or understood. Like the problems experienced with Sucharda's first designs for the *Palacký Monument*, Šaloun's design of 1898 failed due to an excess of descriptive and fragmented details, but in the revised design (1901) the sculptor succeeded in reconciling the required breadth of action

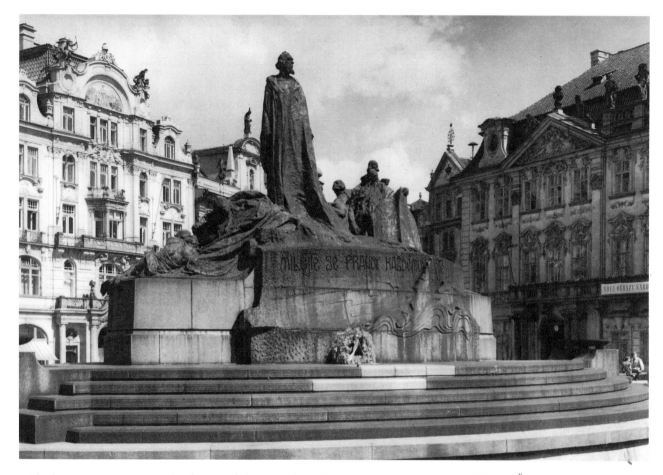

68. Ladislav Jan Šaloun
Monument to Jan Hus, 1900-1915, bronze
Old Town Square, Prague

with the proper stress on the figure of the preacher. During many years of work, adopting or discarding a number of studies for details and variations (some of which were utilised for Šaloun's figure of *Hus* at Hořice (1914)) the Prague monument slowly matured to its final form which was unveiled in 1915. The task set for the sculptor was both ambitious and difficult since it was not only to be a monument to Czech history and Czech national consciousness, but also an appeal to struggle for an independent Czech state. Situated on the Staroměstské náměsti, where the executions had taken place following the disaster of Bilá Hora (the Battle of the White Mountain, when Czech national independence was lost), the monument was to be unveiled in 1915 on the 500th anniversary of the burning of Jan Hus, for heresy, at Constance. This complex web of historical and emotional elements throws much light on the final composition evolved by Saloun and the separate allegorical groups of the oppressed and of defiant determination, whilst the concept behind the monument is emphasised still more by the quotation from the Will of Comenius (1592-1670).

Inevitably there are comparisons to be drawn between the figures of Hus and the defiant men and Rodin's *Burghers of Calais* (1884-94) but any resemblance is to a certain extent due to their response to common problems, though both works share the same concern for

freely modelled surfaces and expressive outlines and a limited interest in structure. Consequently Šaloun's *Monument to Jan Hus* is in most respects the antithesis of Myslbek's *Wenceslas Monument* and, although it is a reflection upon the new vigour of sculpture in Prague that so very different large scale sculptural complexes, together with Sucharda's *Palacký Monument*, could be virtually contemporaneous, it was the example of Myslbek which was to be strongest during the post-First World War period. Šaloun, however, clung to his personal interpretation of Art Nouveau and for the last thirty years of his life he remained an isolated figure of the past.

Quido Kocián

69. Quido Kocián at the time of his return to Hořice

In the highly competitive atmosphere of Prague sculptural circles around 1900, and taking into account the autocratic personality of Myslbek and Sucharda's taste for polemics, it is not altogether surprising that some of the brighter talents did not mature. Quido Kocián (1874-1928) (unlike Myslbek, Sucharda or Šaloun) was trained as a stone carver in the school at Hořice before coming to study in Prague, firstly in the School of Decorative Arts and then under Myslbek in the Academy. Like Sucharda, his was an early response to Art Nouveau and his first independent works are surprising for their imaginative range of decorative invention, with swirling arabesques and expressive outlines, and in his effort to achieve heightened effects of colour in sculpture (in *Šárka* two kinds of marble are combined with alabaster). His highly charged bronze relief *Inhibited Love* (1901) provides a revealing parallel to Sucharda's *Treasure* of 1898, whilst there is a tender defencelessness in his *Portrait of Jaroslav Kocián* (bronze 1900) which perhaps reflects his own personality as much as that of his sitter. He often chose themes which are deeply pessimistic, symbolising pain and the fleeting nature of human existence, and one of his most telling mature works is *Abel* (bronze, 1901). In it the dead body of Abel is guarded by one of Cain's rams and there is an intense melancholy hanging over the low pyramidal composition. The relative economy of Kocián's forms in these sculptures, and his adherence to classical principles of composition, provided a secure foundation, but in slightly later works the emphasis on allegory and descriptive detail becomes disruptive and Kocián was never again to achieve the heights of his best work of *circa* 1900. However, in 1906, after stretching out a travel grant over three years, he gave up the struggle and returned to Hořice as professor, and for more than twenty years he was able to give to his pupils there more than he was able to express in his own work, which so sadly did not live up to the promise and hopes of his younger years.

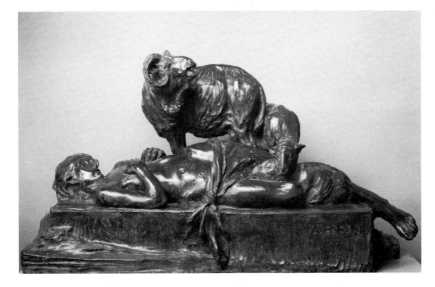

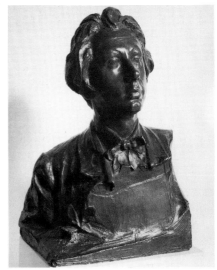

70. Quido Kocián
Abel, 1901, bronze,
67.5 x 132 cm, signed

71. Quido Kocián
Portrait of Jaroslav Kocián, 1900,
bronze, 60 cm.

František Bílek

In the opinion of many scholars, the most talented and original
personality in late nineteenth and early twentieth century Czech
sculpture is František Bílek (1872: 1941), and like Šaloun, he grew up
outside the Myslbek School and his influence. Also like Šaloun,
though for very different reasons, his work did not have any direct
followers or a profound impact on further developments. Whilst in
the majority of works by nineteenth and twentieth century Czech
sculptors we can detect more or less clear marks of the sculptural
traditions of the Czech Baroque, the artistic pedigree of Bílek's
sculpture instead derives from the Late Gothic and is related to the
sculptor's origins in Southern Bohemia. In outlook Bílek was the
most consistent representative of Symbolism in Czech sculpture and
he differed from his contemporaries in his characteristic conception
of form and the resulting attitude to materials and techniques. He
stressed values rather than volumes, and it is not surprising that he
was, at the same time as being a sculptor, an outstanding graphic
artist. From the very beginning of his career he crossed swords with
Myslbek, though it is perhaps more accurate to say that Myslbek,
with undisguised irritation, distanced himself from the young
sculptor who stood for entirely different artistic values to his own.
Bílek had been born in Chýnov, in Southern Bohemia, and studied at
the School of Decorative Arts in Prague (in the sculpture class of
Josef Mauder) and, under the painter Maximilian Pirner, at the
Academy, from which he graduated in 1890. In 1891-92 he studied in
Paris at the Académie Collarossi and then worked independently
from 1892. He exhibited from 1898, with the Mánes Society, and in
Vienna in 1900 (also with the Mánes Society) and whilst his first
one-man exhibition was held in his own studio in Prague in 1904,
most of his work was undertaken in his native Chýnov, near Tábor.
However, of all Czech sculptors, Bílek is the most difficult for
outsiders to understand and the lack of a modern monograph makes

72. Photograph of František Bílek

73. Quido Kocián
Inhibited love, 1901, bronze relief,
146 x 73 cm, signed

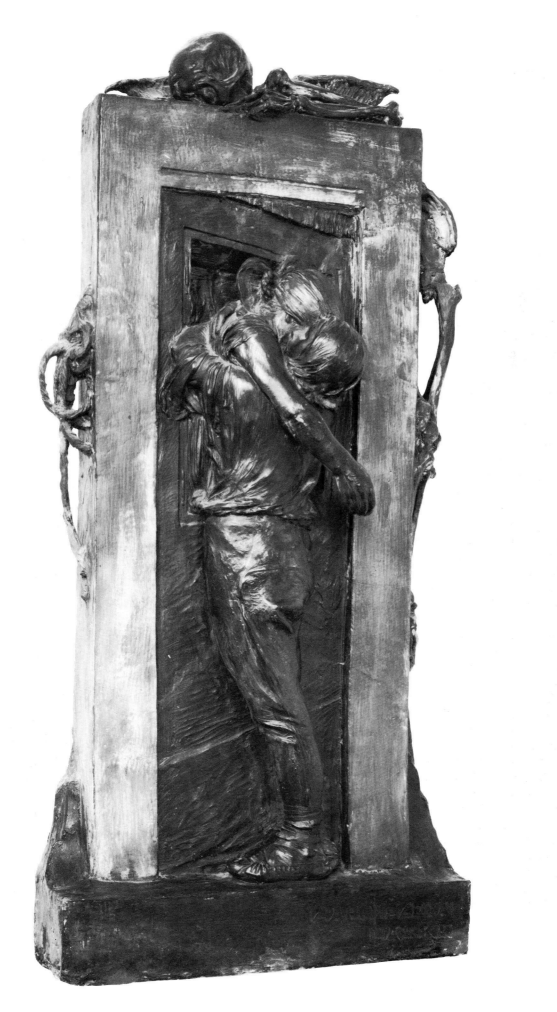

his work additionally difficult to study.

Two works with unusual titles – *Golgotha*, formed of a mountain of skulls, and *Ploughing is Our Punishment for Guilt* – were produced in 1892, at the end of Bilek's two year stay in Paris, and they announced dramatically the debut of a sculptor who, despite his relative youth, was both mature and original. Both works – in the context of Czech sculpture – seem to emerge, without any advance warning, from Bilek's sober and careful drawings made whilst a pupil of Maximilian Pirner at the Academy. Indeed this debut can be compared to the equally sudden and unexpected emergence of the poem *Evening Prayer* which, without advance warning, detached itself from the body of realistic genre prose of Václav Donsovský (Otakar Březina's first *nom-de-plume*), and signified the birth of a major new poet. *Golgotha* and *Ploughing* develop the principles of Antique and Renaissance sculpture which had played the dominant role in Czech sculpture until then, but in their stress on internal actions and spiritual content, as well as emotional experience and communication by means of symbols, they exploit unusually expressive gestures and a highly

74. František Bílek
Interpreting the Word Madonna, 1897, wood,
153 x 93.5 cm, signed and dated

75. František Bílek
Krishna, 1904, wood, 125 cm, signed and
dated

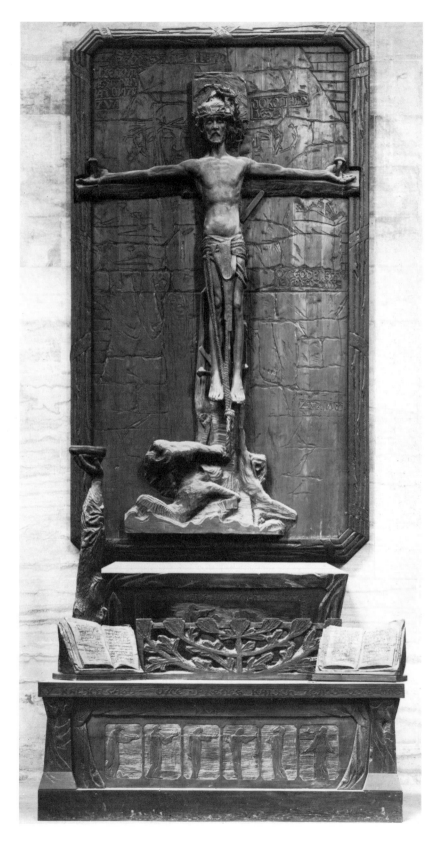

76. František Bílek
Crucifixion, 1896-99, wood
St Vitus Cathedral, Prague

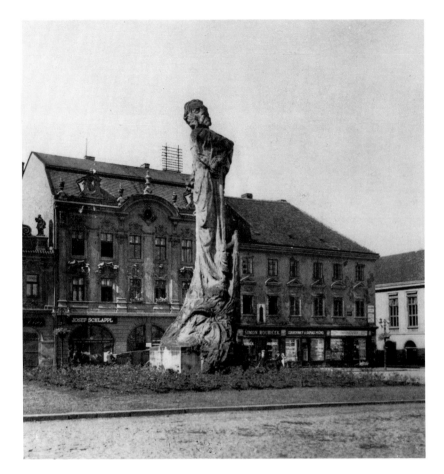

developed narrative. The relationship between the figures and the carefully calculated terrain which they occupy is crucial, as is Bílek's sensitivity for the direct, naked speech of individual objects. Not surprisingly, Bílek found little understanding or appreciation for his art on his return to Bohemia and in consequence he established his studio in Chýnov, and, after completing his military service, he bemoaned his lot in a statue, *Anger of Time – Our Inheritance* (1895).

In its dramatic suppleness and illusive picturesque quality, it combines strong linear outlines with substantial volume, and in some ways it displays the characteristics of its times, which took pleasure in a fluid modelling combined with naturalistic elements. However, the powerful wood relief *Interpreting the Word Madonna* (1897), led Bílek's work into hitherto unexplored waters. Here the sculptor relinquished the media of human figures in favour of an enigmatic layering of shapes and spaces. Spiritual images are permeated with a rythm of forms and symbols, including letters – subsequently used so frequently in Bílek's sculpture and graphic work. The woodcarving, *Parable of the Great Decline of the Czechs* (1898) returns to fully three-dimensional sculpture articulated by movement. The myth of tragedy and pain is expressed by the sprawled figure on a terraced pedestal at the feet of a monstrous figure, represented only by the huge feet and a piece of drapery. A combination of free sculpture and relief is

77. František Bílek
Monument to Jan Hus, 1912, sandstone, over life-size
Kolín

78. František Bílek
Sorrow, 1908-09
Vyšehrad Cemetery (Tomb of Václav Beneš Třebíský)

79. František Bílek
Comenius taking leave of his Mother Country,
1926, sandstone group in the garden of the
sculptor's villa in Prague

80. František Bílek
Portrait of the Poet, Otokar Březina, 1928,
terracotta, life size
Březina Museum, Pocatky

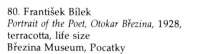

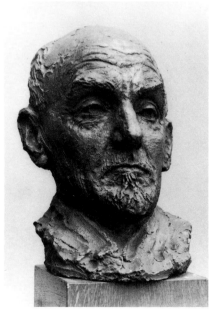

found in the contemporaneous *Crucifixion* (1896-99) carved for
Prague Cathedral. Christ is nailed onto the cross, but at the same
time, as though in mystical ecstasy, the figure rises upwards (the
genesis of the composition, in drawings and other studies , is
documented by the sculptor's correspondence with Julius Zeyer). Of
the same date also are the suggestions of the faces of his mother and
father, hewn out of rough, unfinished blocks intended to serve as a
transome and a corner stone of a window of his house at Chýnov
(1898). Added to this group of works are a number of highly charged
charcoal drawings, which are either preliminary studies or drawings
parallel to the sculptures, and in more than one case constitute
independent works in their own right (*How the Sun's Ray was Dying,
on the Wood of Life* and *Mother!,* both 1899). Also from 1896, the
sculptor was working with the Chýnov potters and created a series of
decorative vases which take their place amongst the most remarkable
Czech ceramics of their time. Thus by the end of the century, the
work of František Bilek was well established on solid foundations and
the broad outlines of his future work were well defined.

During the course of the succeeding years he started to receive
commissions for monumental sculptures, and soon began working on
other projects for large-scale works which came to nothing, but his
successes include the unusually Baroque figure of *Moses* (1905), lost

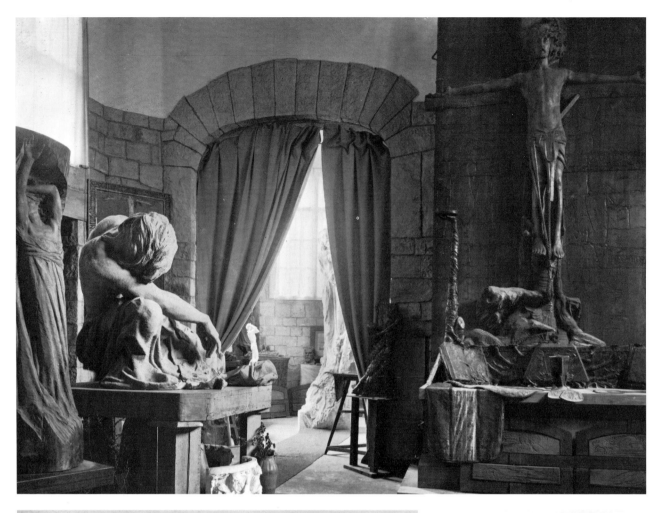

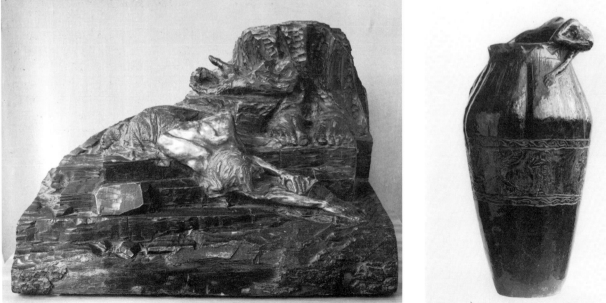

Left
81. View of František Bílek's studio in Prague

82. František Bílek
Parable of the Great Decline of the Czechs,
wood, 52 x 81 cm.

83. František Bílek
Decorated terracotta vase, c. 1900,
43 cm, signed
Museum of Decorative Arts, Prague

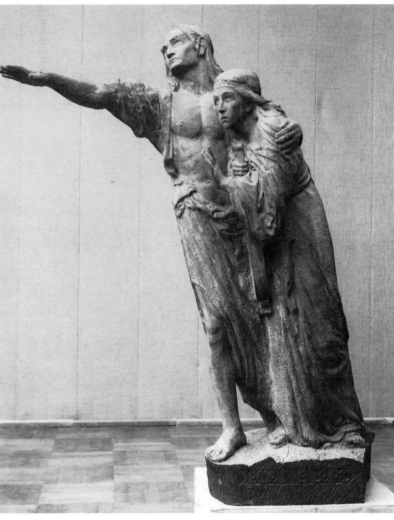

84. František Bílek
The Blind, 1926, wood, 216 cm, signed

in meditation, the robust *Prayer over Graves* (1905), whose moving gesture guards the peace and quiet of the Chýnov Cemetery, and the complex interplay of impulses symbolizing *Amazement* (1907). Several commissions for monuments allowed Bílek to carry out his ideas boldly and without any need to compromise, and the rugged masses and strongly expressive language of *Sorrow* (1908) set up over the grave of Václav Beneš Třebízský in the Vyšehrad Cemetery aroused a storm of protest when first unveiled. Furthermore the *Monument to Jan Hus* at Kolín (1902-12) where the distorted figure of the preacher emerges from flames – expressing the burning intensity of his thoughts and the mode of his martyrdom – was also completely outside the accepted solemn ideas of public memorials. On a more modest scale, Bílek was able to demonstrate his architectonic figural ideas in a group of carved gravestones, frequently decorated with reliefs (see *Opression from the Body, the World and the Vaulting Sky* of 1909). However, all to often he worked in vain on monumental compositions of a very unconventional nature, as may be seen especially in the studies for a *National Monument* and for a *Monument*

to Beauty in Youth and in Struggle. For years he was attracted by the idea of a monument in the form of a whole mountain which he wished to develop from both the figural and architectonic viewpoints. Instead of isolated figures on it, crowds of figures were to be manipulated in broadly developed actions and sculptural *tableaux vivants*, and these ideas have a certain affirmity with those expressed in the poems of Otakar Březina and, later, in the dramas of F.X. Šalda.

In their spiritual and mystical inspiration the sculptures of František Bilek fall unambiguously within the frame of Symbolism, but they cannot be interpreted solely in terms of any single religion, let alone the narrower confines of Christian doctrine. They have a more broadly-based spiritual and metaphysical nature, whilst at the same time they are often decidedly Art Nouveau in design and appearance. The constant two-dimensional stress, expressive outlines combined with soft graduations of modelling, and denial of classical tectonic principals confirms this analysis. Indeed these sculptures often exploit approaches and methods which are patently non-sculptural in order to suggest the breath of a wind, the glow of a fire, the pain of suffering, the flow of ideas or ecstasy. Within the context of Czech sculpture these sculptures were new and special in both conception and realisation, rejecting the commonly accepted limitations of sculpture, and they explored themes extending into multiple dimensions of space and time. Bilek's work is permeated by the particular qualities of modelling – particularly of clay – and of carved wood, rather than those of metal and stone, and in his sculptures he was always endeavouring to find the most direct relationship between an idea and the form it takes in the chosen material, stressing the positive gains to be made from direct carving. Not satisfied with the traditional limitations of figurative sculpture, the mature works of Bilek often speak by means of an abstract language of signs and symbols, of letters and lines. It is truly, in the words to Otakar Březina, 'Sculpture which emerges with music and which is internally aware of the whole bitter secret of movement, expressing the eternal hunger and insatiability of matter, of being parched with thirst, of air, the whirl of worlds, the efforts of nations, the years of prayer' (extract of a letter from František Bilek dated 14 April 1901).

František Bilek's personality was one of exceptional richness and diversity, and in his art he offered a syncretism of the religious ideas of Catholicism and Protestantism, echoes of the philosophical teachings of the new age with old myths of the Orient, the experience of modern literature and that of folk traditions. This breadth of intellectual resources also begins to explain the unusual range of his works which, besides sculpture in wood, stone, clay and metal, also includes hundreds of drawings and graphics, book illustrations and calligraphic texts, ceramics, and occasional commissions in other branches of the decorative arts, and architectonic designs and their realisation. Added to this was his systematic literary activity – the words of a thinker and poet. As Otakar Březina wrote to him 'there is a mysterious unity in the language of your art; an ever new revelation of faith and love, but always one law of syntax

and etymology' (extract of a letter dated 10 August 1904). But where is one to look for the roots and starting point of Bilek's early work: in his beginnings in Paris in the 1890's? In the ideas and images of the Pre-Raphaelites? Or in the exotic atmosphere of contemporary Symbolism? This facet of European culture, so strong in poetry and in painting, did not have a great sculptor. Though the early work of Bilek can, at least at a superficial level, be compared to the wood carvings and ceramics of Paul Gauguin, and perhaps also to Georges Lacombe, or to Georges Minne, it had little in common with the overtly literary style or stylisations of German and Austrian Art Nouveau and Symbolist sculpture.

Among the most interesting later works of Bilek is the statue of *The Blind* for which he produced drawings and sculptural studies from 1901 until he carved the definitive version in 1926. This monumental group was originally intended to be part of a larger cycle based on the idea of life, in which the spiritual expression of Bilek's work was to reach its climax. However the group remained an isolated work and in the same year he carved the strange *Comenius taking leave of his Mother Country* (sandstone, 1926) now in the garden of his villa in Prague. Bilek's numerous portraits form a separate aspect of his work, in a long series ranging in form from the Symbolist *Portrait of the Artist's Father* (1898) emerging from the trunk of a tree, to the realistically conceived and executed *Portrait of the Artist's Son* and *Portrait of the Artist's Daughter* (both 1909) and the sensitive terracotta *Portrait of the Poet, Otakar Březina* (1928) with whom he shared so much.

85. Josef Mařatka
Study of a Man's Hand, 1903, bronze,
18.5 cm

86. Josef Mařatka
Study of Two Women's Feet, 1901, bronze,
23 cm, signed and dated

87. View of the 1902 Rodin Exhibition in Prague

88. Josef Mařatka
Notes for the Rodin exhibition

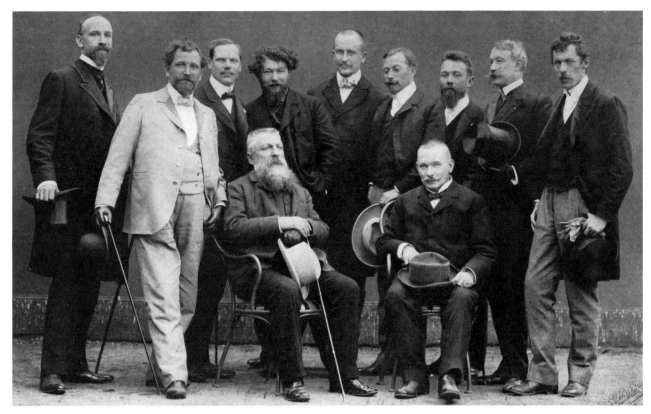

89. August Rodin with the organisers of the 1902 exhibition. From left to right: Ferdinand Herčík, Alfons Mucha, Klenka z Vlastimila, Josef Mařatka, Jan Kotěra, Emanuel Čenkov, Arnošt Hofbauer, Rudolf Vácha, Miloš Jiráner.
Seated: August Rodin, J. Novák.

The Impact of Rodin

As we have seen, the impact of Impressionism on Czech sculpture was greatly delayed, indeed until after both Art Nouveau and Symbolism, and that unlike the other two movements in European art, the sudden impact of Impressionism can be attributed to a single event – the great exhibition of Rodin sculpture held in Prague in 1902. Bohumil Kafka and Josef Mařatka were both deeply influenced by Rodin during the first decade of the new century and it was through them and their work that the ideas of Rodin and of Impressionism were developed briefly in Bohemia.

Josef Mařatka (1874-1937) was a native of Prague and received his basic training, under Myslbek, at the School of Decorative Arts there (1889-92). Later he was among the first group of pupils which Myslbek received when he started the School of Sculpture at the Academy of Fine Arts (1896), and Mařatka studied a further three years there. Consequently it is only to be expected that his earliest work is heavily dependent upon Myslbek, and it is of relatively limited interest. However during the years 1901-1904 he worked in Paris, and in 1901-02 in the atelier of Rodin, mostly in connection with organising the Rodin Exhibition in Prague. His working drawings for the exhibition provide an insight into the process of selection of the works but, more importantly, the impact of Rodin's style and working methods on him was electrifying. The extent to which Mařatka combined an interest in Art Nouveau with the art of

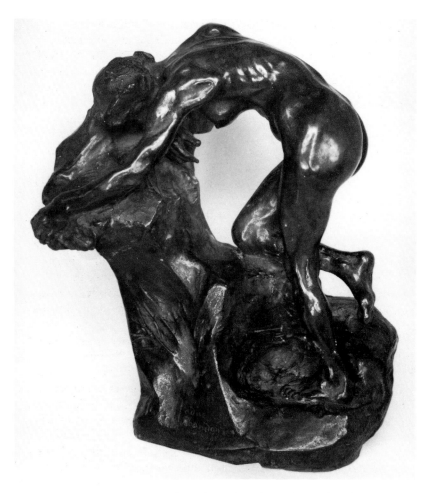

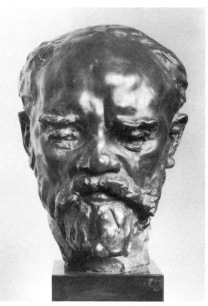

90. J. Mařatka
Antonin Dvořák, 1906, bronze, 34 cm, signed

91. Josef Mařatka
Desolate Ariadne, 1903, bronze,
31 cm, signed

Rodin is open to considerable debate, but the relationship between the young Czech sculptor and the French master has often tended to be misunderstood. Mařatka, in as much as he ever worked for Rodin, was employed as a *practicien* in Rodin's atelier and was never a pupil. Rodin employed a growing number of specialist craftsmen in his atelier as he grew more successful, including many highly skilled *practiciens* who would cut his marble and stone sculptures, under his close control, from his plasters. He never took students and indeed there is strong evidence to suggest that he avoided revealing his working methods to those who sought an understanding of them, often referring them instead to his old *practicien*, Antoine Bourdelle. Mařatka developed a huge admiration for Rodin during the time of the exhibition, and was with him in Prague, so that on his return to Paris in 1902 Mařatka began to produce sculpture which is totally in the spirit of Rodin.

In *Study of Two Women's Feet* (bronze, signed J. Mařatka, Paris, 1901) he had already revealed a direct response to some of the more idiosyncratic compositional ideas of Rodin, and after his return he modelled the *Study of a Man's Hand* (bronze, signed J. Mařatka, Paris, 1903) which shows him as dependent upon Rodin as he had been upon Myslbek during the 1890's. Also executed in 1903 are *Wave*,

Study of a Female Nude and *Desolate Ariadne,* and both are of exceptionally fine quality with their broken flickering surfaces, expressive silhouettes and strong rhythmic modelling. On his final return to Prague, in 1904, Mařatka took back with him these lessons and his lively *Portrait of Antonin Dvořak* (1906) the dramatic modelling expresses well the creative energy of the composer and there is no trace of either Art Nouveau or Symbolism. For a few years he remained faithful to Impressionism, in the *Portrait of Vlasta Zindlová* (1907-08) and the *Portrait of Teresa Koseová* (1909), but by around 1910 some of the liveliness had been lost and much of Mařatka's heavy, realistic sculpture for the New Town Hall in Prague (1911-12) is very disappointing. This apparent volte-face, with the reassertion of the influence of Myslbek, can be seen in terms of a deliberate return to Czech models, and Mařatka's later, extensive work on monuments and decorative architectural sculpture reveals a total rejection of his Impressionist period during the first decade of the century. From 1920 until his death in 1938 Mařatka taught at the School of Decorative Arts in Prague and thus much of his later influence was exerted as a teacher rather than through the medium of his finished sculpture.

The background of Bohumil Kafka (1878-1942) was very different to that of Mařatka and their response to Rodin and French Impressionism differed considerably. Born at Nova Paka, Kafka first studied at the School for Sculptors and Stone Masons at Hořice (1891-95) and worked briefly as a stone mason and stuccoist in Dresden and in Bohemian towns before studying at the School of Decorative Arts in Prague under Sucharda (1896-98) and at the Academy under Myslbek (1898-1901). In 1902 he too visited Paris and the atelier of Rodin, probably in connection with the Rodin Exhibition, and he returned to Paris in 1904 to work for four years in Rodin's atelier. This was again undertaking the technically exacting work of a *practicien* which enabled Kafka, like so many other young sculptors of every nation coming to Paris from 1900, to earn his living whilst leaving him with sufficient free time to develop his own ideas independently. His earlier training as a stone carver at Hořice stood him in excellent stead and it was by choice that he abandoned the Art Nouveau and Symbolist elements in his early style – for example the *Dead Swan* of 1900 – turning instead to Rodin as his principal source of inspiration, though he never to the same extent as Mařatka. At the outset of this period the robust, lively realism of his marble *Portrait of Mikuláš Aleš* (1902) on his tomb in the Vyšehrad Cemetery provides a telling contrast to the fluid modelling of his portrait of and old woman entitled *Ruin of Life* (bronze, 1902). From Paris Kafka supplied a number of tomb sculptures, including that of the Jirásek family in the Vyšehrad Cemetery (1904) in which the motif of his earlier studies became a metaphor for death. Over the body of the swan looms the figure of an angel whose powerful outspread wings touch those of the bird, and his masterpiece of funerary sculpture, the *Tomb of Dr Jindřich Kaizl* (1907), is also in the Vyšehrad Cemetery. Exploring the theme of 'The Embrace of Love and Death', the sculptor developed in the figure of the angel with

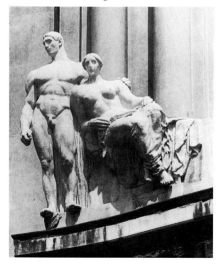

92. Josef Mařatka
Allegory of Persistence, 1911-12, artificial stone group, life size
New Town Hall, Prague

outspread wings a remarkable fusion of solemnity and spiritual exaltation, and the almost delicate modelling of the volumes and drapery, ruffled by a light breeze, is in complete harmony with the precision of the composition.

Kafka's response to the sculpture of Rodin is perhaps best seen in one of his most informal compositions undertaken in Paris – *Roe Deer with Young* (1905) in which the spontaneous freedom of the handling and the brilliant observation and dexterity of modelling, mark it, together with his exquisite maquettes, *Woman raising her Dress* (1905) and *Woman arranging her Hair* (1906), as some of the purest manifestations of Czech Impressionist sculpture. However he remained receptive to a wide range of other ideas: for example, the air-dried Peruvian mummies exhibited in Paris during his stay were recorded in the slightly sinister bronze *Mummies* (1905). Equally strange, though stylistically more indebted to Rodin, is the audacious *La Sonambula* (bronze, 1906). The striding figure of the sleepwalker, harrassed by owls, seems to have become almost weightless, with the excitement of the action countered by the dreamlike insubstantiality of her body. Also of 1906 are the utterly different reliefs *Bathing in the Sea* and *After Bathing in the Sun* which instead reflect a calm and sunny mood with figures in a soft, vibrating light, and whose limits are clearly defined by the decisive outlines. This last stylistic facet of the varied work undertaken by Kafka in Paris can now be seen to prefigure the stylisation evident in the *Memorial to J.P. Presl* (relief, 1909) and the reliefs depicting *Flora* and *Fauna* in the vestibule of the Obečni Dům (1910). He established a considerable reputation in Paris, with a one-man exhibition at the Galerie A.A. Hébrard in 1906, and works exhibited at the Salon of the Société National des Beaux-Arts, whilst in 1908 he exhibited twenty-three works in the Salon d'Automne. To the last years of his stay in Paris belong the impact of the sculpture of Maillol and Bourdelle, and the year after Kafka's return to Prague the large scale exhibition of the works of Antoine Bourdelle was displayed there by the Mánes Society. However, like Mařatka, Kafka withdrew steadily from his enthusiasm for French sculpture and veered increasingly towards the Czech realist tradition.

This process is well documented by the portraits produced by Kafka since, apart from the major monument executed between the two World Wars, this rapidly became one of his major spheres of activity. Some of his portraits of 1909-11 – including the *Portrait of Dr. Albin Bráf* (bronze, 1911) – document the move away from the French liveliness of surface handling towards more sober modelling and emphasis on plastic solidity, and these qualities have taken over in the unfinished marble bust of *Jindřich Mošna* (1913) in the National Theatre in Prague. The later material successes of Kafka, including the execution of the huge *Monument to Jan Žižka* (set up 1950) which dominates Prague from the Vitkov Hill, were not always paralleled by the quality of his artistic imagination and the cold stereotyped musculature of his theatrical figure of *Orpheus* (1921) must have provided a very strange contrast to the work of the new generation which emerged after the First World War.

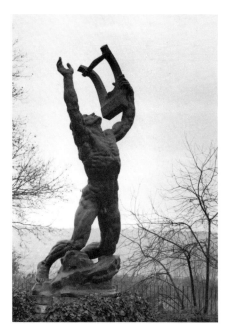

93. Bohumil Kafka
Orpheus, 1921, bronze, 275 cm, signed and dated

94. Bohumil Kafka
Roe Deer with Young, 1905, bronze, 29.5 cm, signed

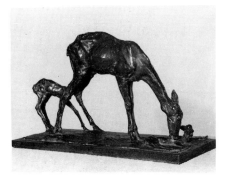

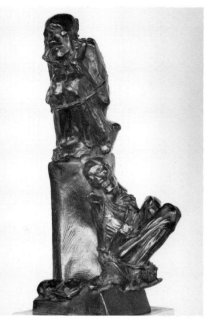

95. Bohumil Kafka
Mummies, 1905, bronze, 67 cm, signed

96. Bohumil Kafka
La Sonambula (The Sleepwalking Woman),
1906, bronze, 77 cm, signed and dated

97. Bohumil Kafka
Ruin of Life, 1903, bronze, 73 cm, signed
and dated

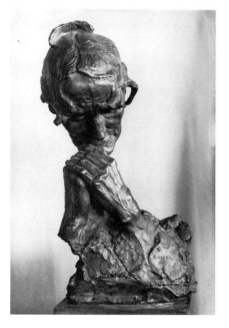

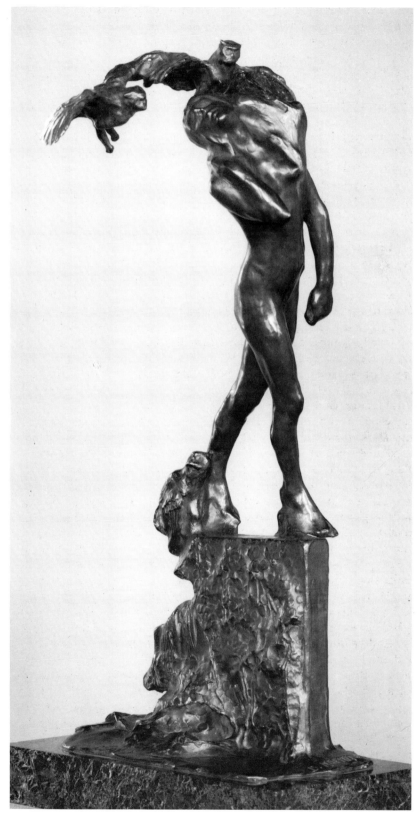

Jaroslav Horejc

Whereas 1902 brought Rodin and French Impressionist sculpture to Prague, 1909 saw the great exhibition of Emile Antoine Bourdelle, mounted again by the Mánes Society. One more Mařatka appears to have played an important role in the organisation, and in his speech of thanks during his visit Bourdelle referred specifically to him and Kafka, as well as Jan Dedina and Stanislav Sucharda. Both Mařatka and Kafka were in Paris for Bourdelle's large one-man exhibition at the Galerie A.A. Hébrard in 1905 when he exhibited thirty-eight sculptures and a number of paintings, pastels and drawings. Elie Faure wrote the introduction to the catalogue and noted in it the tempering of Bourdelle's natural lyricism by the structural discipline which he had evolved around 1900. Bourdelle's *Head of Apollo* (1900) is in this respect a key work and the parallelism exhibited by Bourdelle and Maillol in their contemporary movements towards more classical modes during the first decade of the new century is not entirely coincidental. Indeed Maillol had begun to develop the almost geometricised classicism of his early statuettes from 1899 and, editioned by Vollard, his first exhibition was at Vollard's in 1902 when both Mařatka and Kafka were in Paris. However, whilst Mǎratka, Kafka and Kofránek responded to the sculpture of Rodin, Jaroslav Horejc (born 1886) looked instead towards the more classical modes being developed by the younger generation of sculptors and in particular the archaic qualities of the early Maillol sculpture which are deliberately conceived in terms almost of relief sculpture. Bourdelle's classicism during the latter part of his career (after 1900) is both less extreme and more personal, and is closely related to his deep concern for structure. This was the complete antithesis to Rodin's concern for expressive outlines and freely modelled surfaces, and thus the position of Bourdelle as the principal teacher in the Académie Rodin in 1900-09 must have been increasingly difficult. Apart from taking pupils into his own ateliers, Bourdelle broke with the Académie Rodin in 1909 and until his death in 1929 taught instead at La Grande-Chaumière. Rodin's refusal to take pupils meant that many a young sculptor was thrust into the arms of his more articulate assistants, above all Bourdelle who had a great gift for teaching. Indeed the importance of Bourdelle's teaching for students from Central and Eastern Europe, including Otto Gutfreund, has been too often seriously underestimated.

Bourdelle's first great public success, his *Heracles the Archer*, was first exhibited at the Salon de la Société National des Beaux-Arts of 1910, after the Prague Exhibition, but an early cast was purchased for Prague and is now displayed in the gardens of the Šternberck Palace there. However, for Jaroslav Horejc, it was more the Bourdelle of the reliefs for the Théâtre des Champs-Elysées (1910-12) which interested him, and in Horejc's *Dancer* (1912), *Venus* (1914) and *Orpheus* (1916) the impact of this stream of French sculpture is clearly apparent. However, to the deliberate archaising qualities of the early works of Maillol, and the relief style of Bourdelle, Horejc added a strong sense of the decorative, with deliberate contrasts of colour and jagged

98. Antoine Bourdelle and the organisers
of his exhibition in 1909. Left to right:
Jiránek, Myslbek, Štech, Bunaud, Mařatka,
Bourdelle, Sucharda, Čenkov, Bílek.

99. Bohumil Kafka
Portrait of Dr Albín Bráf, 1911, bronze,
56 cm, signed and dated

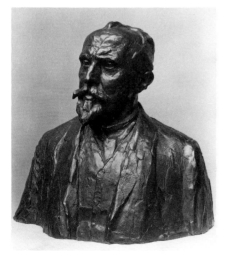

compositions. Often characterised as Art Deco, these qualities are
well developed in his more complex compositions of these years,
including the bronze relief of a *Madonna and Child with Music-playing
Angels*, in the Olšanské Cemetery in Prague (Rivnáčov family tomb,
signed but not dated). Much of Horejc's activity from the early 1920s
until well into the 1930s was in the design and production of glass,
though his carved wooden statuette of *Samson* (1935) also draws its
inspiration from German *kleinplastik* and the South Bohemian
alabasters of Lazar Widman (1699-1769). Horejc's sculpture remained
isolated, though popular in certain circles, and the impact of the
classicism of Bourdelle and Maillol was as short-lived in Bohemia as
that of the Impressionism of Rodin.

100. Jaroslav Horejc
Orpheus, 1916, wood

101. Jaroslav Horejc
Venus, 1914, bronze, 28 cm, signed

102. Jaroslav Horejc
Dancer, 1912

103. Jaroslav Horejc
Samson, 1935, wood, 50 cm, signed

104. František Uprka
The Hoer, 1908, bronze, 39 cm.

105. František Uprka
The Thresher, c. 1910, bronze,
68 cm, unsigned

František Úprka

The great Ethnographical Exhibition held in Prague in 1895 made readily accessible themes and forms to which many sculptors responded, including Sucharda, Kocián and Kafka (see Kafka's *Harvest* of 1902) but their varied responses were short lived. In contrast, the life of the people in the countryside, and Southern Moravian folklore, provided the monothematic basis of all the work of František Úprka (1868-1929), much of whose finest work belongs to the first decades of the century. There was much in him of the temper and customs of the village carver and stone-cutter, who would apply his untutored talents in occasional and very varied tasks – gravestones and altars, decorations for public and private buildings, portraits and even monumental sculpture. The first works of Úprka date from the late 1890s and achieved some public success because of the general interest in genre sculpture with an ethnographic basis, and even after this taste disappeared he did not relinquish his love of these subjects, so close to his own experience. Like his painter brother Jažra Úprka, he remained closely tied to the confined but colourful world of the borders of Moravia and Slovakia, living and working in his native Kněžduba and the surrounding villages under the slope of Šumárnik, in the long wine-growing plateau of Padluži, or in Veličány. The sculpture of František Úprka is not ambitious, but the simple genre figures have a directness and integrity which is deeply impressive. Works such as *The Hoer* (1908) and *The Thresher* (*circa* 1910) emphasise the strong and varied roots of the Czech realism which was to flower in the 1920s, whilst his monumental works like the *Peasant Girl gathering Lilies* on the Urban family tomb in the Olšanské Cemetery (*c.* 1918) have a serene tranquility which totally transcends their humble subject matter.

The Earlier Sculptures of Jan Štursa: 1900-1914

Born in Nové Město na Morave, in the hills and forests on the border between Bohemia and Moravia, Jan Štursa (1880-1925) first studied at the School for Sculptors and Stonemasons at Hořice (1894-98). He worked briefly as a stonemason in a quarry at Mittelstein, and in Berlin, before entering the Academy of Fine Arts in Prague to study under Myslbek (1899-1904) and his earliest important sculptures date from this period. The lithe, sensuous figure of a *Girl Holding her Breasts* (bronze, 1901), almost life-size, is something of a *tour-de-force* for a twenty-one year old sculptor and betrays rather more of the impact of Art Nouveau than would have met with the approval of his mentor, Myslbek. Nevertheless, the female nude figure was to become the centre concern of Jan Štursa as a sculptor and the sensuality without eroticism displayed at this early date was to be a hallmark of his female nudes throughout his career. The strong element of realism in Štursa's style had already manifested itself in his earlier sculptures, the *Brickmaker* (1900) and *Woman Hoeing* (1901) which belong to the brief period of popularity for such genre subjects which we have seen already in connection with Úprka. These two lively genre pencil sketches were probably made in Štursa's homeland for the sculptor never lost contact with his roots there.

Notwithstanding its realistic treatment and deep poignancy Štursa's bust of a tubercular woman entitled *Fading Life* (1904) continues to display the fluid modelling preferred by the Czech Art Nouveau sculptors, but in his sad and slightly ungainly nude figure of a girl, *Puberty* (1905), its uncompromising realism is the hallmark of Štursa's mature style. In her angular, partly developed body he blends a tenderness with almost clinical observation, and the young country girl is naked rather than nude, though the resemblances to the later drawings of Klimt and Schiele are almost certainly fortuitous. However she does share the same quality of innocence and defencelessness with Kocián's *Portrait of Jaroslav Kocián* of 1900. The erotic content of some of the sculptures made during Štursa's years in the Academy had infuriated Myslbek, despite their close links to literary themes, and after the conflict Štursa had for a time submitted rather more to the discipline of the Myslbek atelier. The austere personality and discipline of the old master provided a counter-balance to his own explosive temperament, and Štursa recognised that without the methodical training of Myslbek his own varied talents could be lost in frantic experimentation and dissipation of his energies. After his flirtations with Impressionism, Symbolism and Art Nouveau, Realism was re-established in *Puberty* and, in the same year (1905), by the stone figure of a shepherd boy holding a sheep in his arms, entitled *Song of the Mountains*.

Made for the lower square of his native town of Nové Město and carved from sandstone, this homely group, set in the middle of a fountain, faces the life-size figure of *František Palacký* which Štursa had carved from Hořice sandstone for the town in 1902. In *Song of the*

106. Photograph of Jan Štursa

107. Jan Štursa
Girl holding her Breasts, 1901, bronze,
162 cm, signed and dated

108. Jan Štursa
Puberty, 1905, bronze, 43 cm, signed

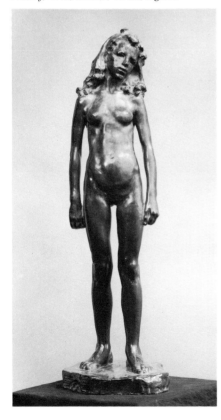

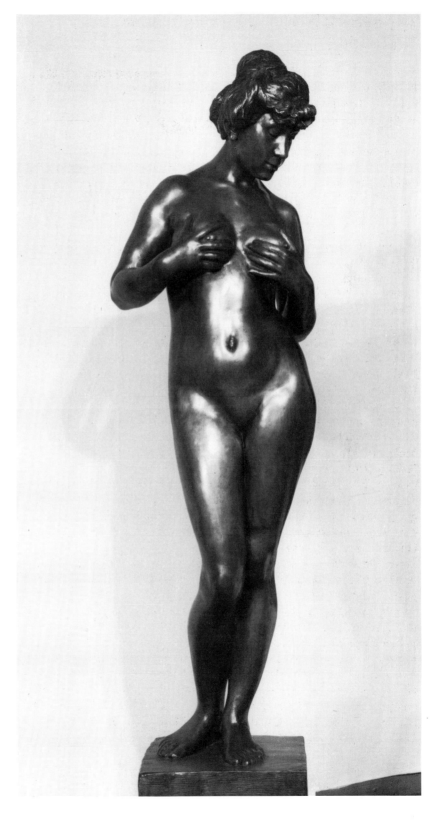

Mountains Štursa reasserted, unequivocally, his artistic origins and the deep feeling for his materials learnt at Hořice. The boy is one with the block of stone out of which he has been freed and although not carved direct, its handling points the way to the limestone figure *Appassionato*, executed in the following year, which is. The period 1900-1912, in which the mature female nude formed Štursa's central theme, was perhaps his period of greatest achievement and in *The Melancholic Girl* (1906), carved from deep grey French limestone, he created one of the great masterpieces of Czech twentieth-century sculpture. The richness of the volumes and the sensuality of her forms are held in delicate balance by the strong sense of discipline, and here Štursa's sensuality and understanding of the qualities of his stone are wedded brilliantly to the discipline instilled by Myslbek. During this period the type of woman depicted by Štursa gradually changed from the young, thin *Melancholic Girl* to the older and fuller forms of *Eve* (bronze, 1909), and thence to the richly voluptuous curves of *Washing the Hair* (marble, 1908, retouched 1924) and *Toilet* (marble, 1910, retouched 1923). These psychologically uncomplicated figures with their ample flowing curves owe a limited amount to Renoir and French Impressionist painting, rather than French sculpture, and it is worth emphasizing that unlike Mařatka and Kafka who worked alongside Rodin and others in Paris, Štursa's experience was based on repeated short journeys abroad and the series of exhibitions brought to Prague during the first decade. Consequently the synthesis achieved by Štursa in his mature works of 1906-12 retained a much larger Czech foundation than the contemporary work of Mařatka and Kafka, and even in the great marble nudes the spirit of Hořice is close to the surface.

In 1908 Jan Štursa was commissioned to undertake the sculptural elements for the Pavilion of Commerce and Industry designed by Jan Kotěra for the Jubilee Exhibition of the Chamber of Commerce and Trade in Prague. Executed in lime, cement and sand, these were destroyed soon after the Exhibition closed, but the groups of monumental female figures in the Court of Honour of the Pavilion and the large high reliefs depicting *Commerce* and *Industry* flanking the main entrance opened up a whole new field of sculpture to Štursa, one which was to include many of the most important works executed by him before the outbreak of the First World War. Meanwhile his treatment of the female nude took on a new robustness and vitality in the vigorous figure of *The Dancing Girl, Sulamit Rahu* (bronze, 1910-11). Her muscular body, almost grotesque in the firmness of its forms, might be interpreted as a stylistic development pure and simple were it not for the photographs taken of her posing in Štursa's studio. These demonstrate the strength of Štursa's faithfulness to realism in modelling her figure and the extent to which its Baroque qualities were those of the model herself. However, it was the body of Sulamit Rahu, rather than the softer, more lyrical forms of his earlier nudes, which pointed the way to the Hlávka Bridge groups. In the marble figure of *Messalina* (1910-12, reworked 1913) the flesh is already much firmer and a new, heroic type of nude begins to take over from the uncomplicated peasant

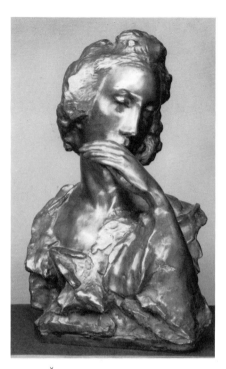

109. Jan Štursa
Fading Life, 1904, bronze, 54 cm

111. Jan Štursa (right)
Melancholic Girl, 1906, limestone, 43 cm, signed

110. Jan Štursa
Appassionato, 1906, limestone, 33.5 cm.

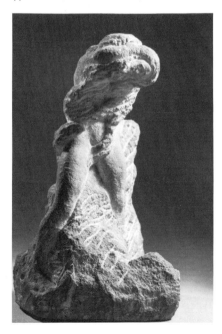

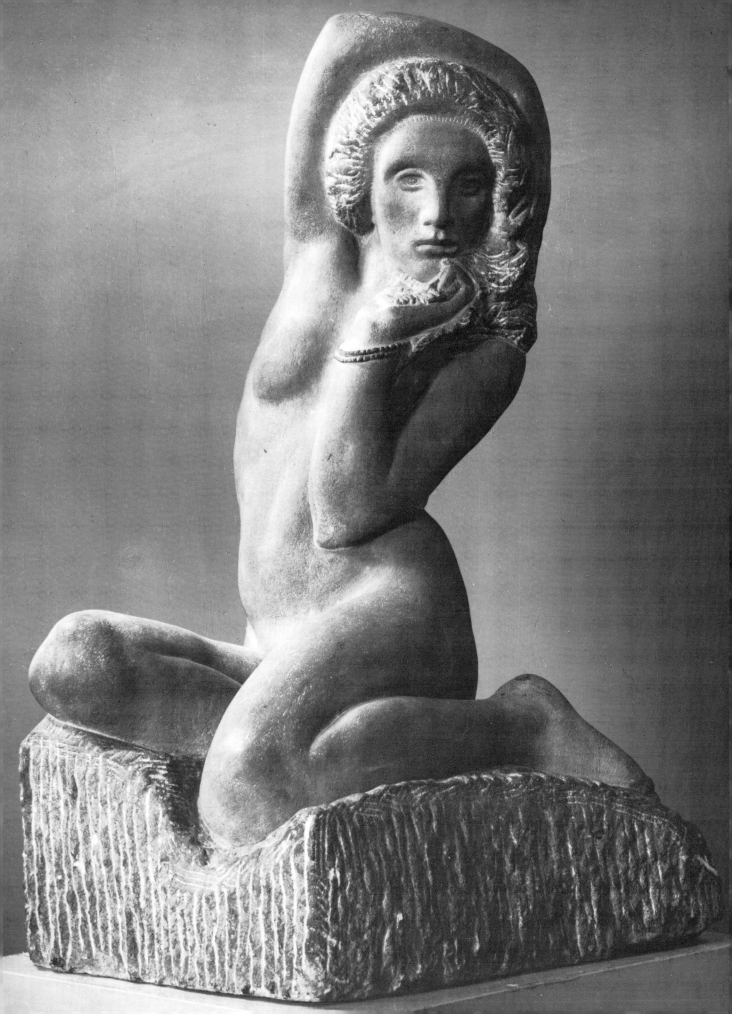

Stupsa

112. Jan Štursa (left)
Toilet, 1910 and 1923, marble,
120 cm, signed

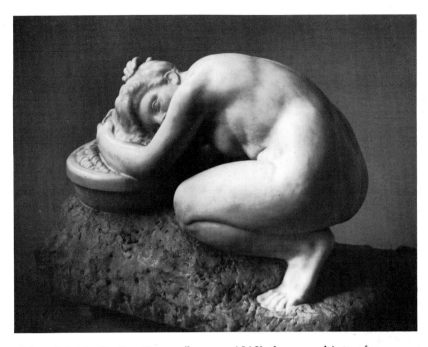

113. Jan Štursa
Washing the hair, 1908 and 1924, marble,
68 cm, signed

114. Jan Štursa
Eve, 1909, bronze, 190 cm, signed

girls, whilst in *Resting Dancer* (bronze, 1913) there are hints of a
return to Štursa's much earlier sophistication. The slightly ambiguous
pose is more explicit in certain of the drawings for this figure or
developing this theme, but these drawings are also particularly
valuable in assessing the range of ideas and sculptural language
which he was exploring in 1913. In them are echoes of not only
Matisse but also some of his earliest flirtations with Cubism and
Vorticism.

Aside from the main line of development in Štursa's work during
these years was his *Monument to Hana Kvapilová* (1909-12). The great
actress had died prematurely, but she had expressed so clearly many
of the ideals and the fervour of the turn of the century, both in her
interpretations of characters in the plays of William Shakespeare and
Henrik Ibsen, and in her recitals of works by contemporary Czech
poets. Since the sculptor had not known her personally, he had to
work from photographs and written reports, together with the
recollections of her contemporaries and friends. A whole series of
studies survive, with variations of both the standing and seated
figure, her hands calmly folded or raised to the head in a gesture of
listening or searching for inspiration. Others document his evolution
of the folds in the draperies and changes in expression of her face,
whilst the studio photographs taken of a model in the pose of the
final sculpure are very revealing. Executed in marble, the monument
now stands in the Kinsky Park at the foot of the Petřin Hill in Prague
and provides an excellent compromise between the demands for an
accurate record of the appearance of the great tragic actress and the
spirit of her acting.

In many respects the climax of Štursa's sculptural development
before the outbreak of the First World War, and his most
monumental works, are the two groups decorating the pylons of the

Hlávka Bridge in Prague (1912-13). Štursa collaborated with the architect Pavel Janák and the closely-knit multifigure compositions represent *Work* and *Humanity*. Starting with small sketches and models, exploring four variants for each, Štursa progressed via one-fifth-scale and half-size maquettes to the full-scale works carved in sandstone. These are 4.50m in height and were originally installed on the bridge in June 1913, but they were removed during the reconstruction of the Hlávka Bridge in 1956 and placed in store, to be returned to their new pylons in 1983.

The heroic proportions of the nude figures (including the self-portrait of the sculptor) and the emphasis placed upon the very firm, well-developed musculature of both the male and the female figures – anticipated in the *Salamit Rahu* and *Messalina* sculptures – reveals Štursa's changed attitude to the nude. Indeed the character of the figures was closely in tune with the growing radicalism of both Štursa and contemporary Prague, and the symbolism of the strong mixed groups of rugged men and women displaying such inner coherence and rock-like stability was apparent to all.

Furthermore, the powerful verticality of the groups, growing out of the high tapering pylons, counters the horizontal lines of the bridge and in the dynamic relationship between the sculpture and the bridge is echoed the partnership between the architect and the sculptor. Štursa, in the same years, also collaborated on the decoration of the central pier of the Mánes Bridge in Prague (1913) with massive curved granite reliefs representing *Beauty* and *Art*. The maquettes, more than the finished reliefs, reveal Štursa's attraction to Cubist forms and compositions, here transposed from painting rather than from the experiments of Otto Gutfreund.

Clear influence of the forms of Cubism are also evident in the competition designs evolved by Štursa in partnership with Jan Kotěra for the *Monument to Jan Žižka of Trocnov* (1913) to be erected on top of the Žižkov hill overlooking Prague and visible from more than half the surrounding horizon. The monument was to be be an architectonic mass in which sculpture and architecture were fused together, and the simple elemental forms of the mounted figure of Jan Žižka (legible from several miles away) were to be supported, both visually and spiritually, by the ranks of foot soldiers alongside him, their shields raised over their heads to form a powerful rhythmic composition. Despite the first impression of heaviness, the proposal was highly imaginative, and, if carried out, would have been a landmark in European memorial sculpture. The partnership between Štursa and Kotěra was always stimulating for both, even in such modest tasks as the caryatids depicting *Music* and *Song* which Štursa carved for the facade of the Urbánek Building in Prague (1912-13), designed by Kotěra. This growing sense of unity between sculpture and architecture was an important characteristic of Štursa's sculpture immediately before the outbreak of the First World War, and the elemental, block forms of the massive rebel figure which forms the *Monument to the Peasant Uprising* at Dolni Újezd, near Litomyšl, carved by him in 1913-14, suggest the influence of the ideas of Antoine Bourdelle. The tapering pedestal, with its heads of

115. Jan Štursa
Decoration of Pavilion of Commerce and Industry, Prague Jubilee Exhibition, 1908, cement, destroyed

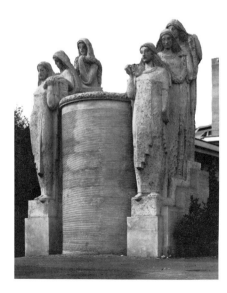

116. Jan Štursa
Decoration of Pavilion of Commerce and
Industry, Prague Jubilee Exhibition, 1908,
cement, destroyed

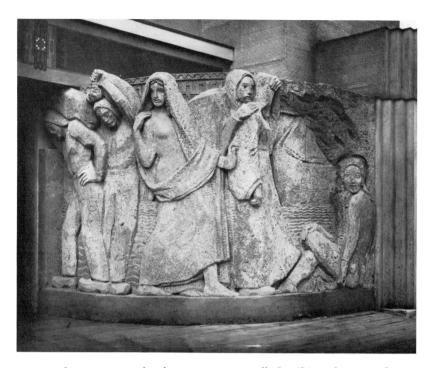

executed peasants at the four corners, recalls Janák's pylons on the
Hlávka Bridge and the heroic, revolutionary character of the figure is
developed from those groups. The driving force behind Štursa's
change in style is expressed with exemplary clarity in his oval jubilee
medallion entitled *May Day, 1890-1914*, where the figure of the man
with a flag and the self-confident, militant pose prefigure later
developments in Czech sculpture. At the outbreak of the First World
War Štursa had been intending to travel to Paris for a longer stay, for
he wished to work for some time in the atelier of Antoine Bourdelle.
Instead, on 3 August 1914, he joined the 81st Infantry Regiment at
Jihlava and during the months which elapsed before the end of 1916
he carried out little sculpture of significance.

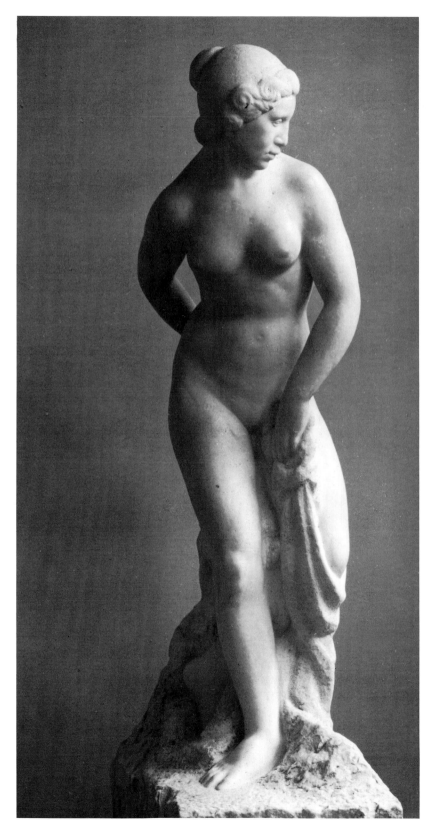

117. Jan Štursa
Messalina, 1910-12, marble, 166 cm, signed

118. Jan Štursa
Sulamit Rahu, 1910-11, bronze,
196.5 cm, signed

119. Jan Štursa
Resting Dancer, 1913, bronze, 118 cm,
signed

121. Jan Štursa
Work, 1912-13, sandstone,
over-life-size
Hlávka Bridge, Prague

120. Jan Štursa
Humanity, sandstone, 1912-13,
over-life-size
Hlávka Bridge, Prague

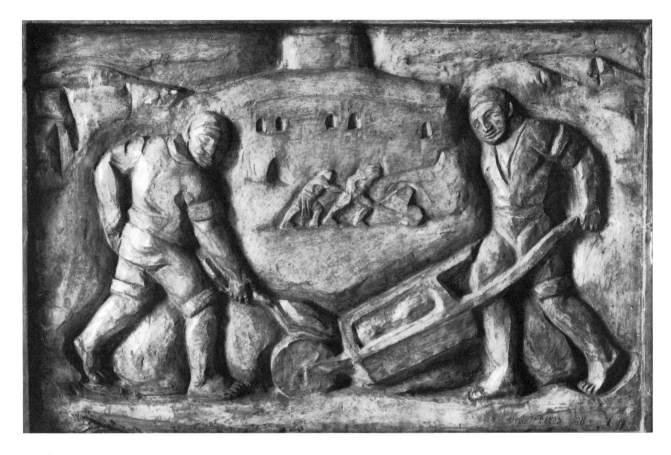

Otto Gutfreund: 1910 - 1919

A native of Dvůr Králové nad Labem, Otto Gutfreund was educated there and studied at at first in the School of Ceramics at Bechyně from 1903, but in 1906 he came to Prague and studied under Drahoňovský at the School of Decorative Arts. The solid instruction which he gained at the latter by no means supplanted the skills which he had developed in Bechyně and for all his career Gutfreund was by instinct a modeller rather than a carver. This was in sharp contrast to the background of stone carving – directly or indirectly linked to Hořice – which was shared by the majority of Czech sculptors, not least his contemporary, Jan Štursa. Furthermore, the impact of the Rodin Exhibition in 1902 had been less strong on Gutfreund than on many others (Otto Gutfreund was only aged thirteen at the time and had not started his formal studies) whilst the shock waves of the Munch Exhibition in 1905 were not so strongly felt in Běchyne as in Prague. The same could not be said for the great Bourdelle Exhibition mounted in Prague in 1909, when Gutfreund was completing his studies at the School of Decorative Arts, and Maratka introduced the young sculptor to the French master. With his father's support Gutfreund followed Bourdelle to Paris and studied under him at La Grande-Chaumière from 1909 to 1910, working for the last few months in Bourdelle's ateliers in the Impasse

122. Otto Gutfreund
Brickmakers, 1911, plaster relief, 45 cm, signed

123. Photograph of Otto Gutfreund

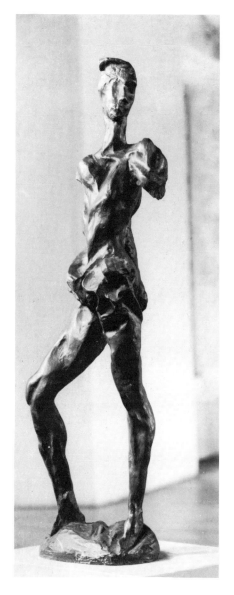

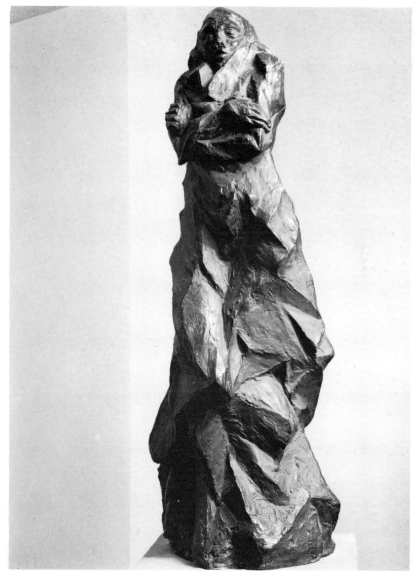

124. Otto Gutfreund
Hamlet, 1911, bronze

125. Otto Gutfreund
Hamlet, 1911, bronze, 70 cm.

du Maine. At first he was not greatly interested in the latest ideas of the Modern Movement, and spent much of his time in the Louvre studying Classical and Gothic art. This was in accordance with the theoretical ideas of Bourdelle who encouraged his pupils to develop their own ideas, provided they were based on a sound understanding of the sculptural values of earlier periods.

One of his closest friends at the time, Antonin Matějček, wrote of him then 'what was surprising in this young sculptor was his exceptional intelligence, literary education, certainty of judgement and developed sense of cultural values' and to a certain extent his response to the wide range of ideas made accessible to him in Prague and Paris was encouraged by his traditional Czech Jewish family background. Gutfreund's earliest sculptures, executed before 1910, are neither distinguished nor particularly revealing of his later

development, but in his *Head of Antonin Matějček* (1910) the impact of the architectonic structures of Antoine Bourdelle are evident, whilst the continuous smooth modelling of the surfaces both looks back to his training in terracotta at Bechyně and anticipates his sculpture of the 1920s. Gutfreund noted in his diary: 'to be a sculptor it is not enough to be able to model: a sculptor must be a mathematician who fashions his material according to a preconceived plan, thus also an architect,' and, if not a direct quote from Bourdelle, these words follow faithfully the ideas that he put forward during the sessions at La Grande-Chaumière. Matějček, subsequently a leading Czech art historian and critic, was responsible for the selection of work by members of the Salon des Indépendents which were exhibited in Prague in February 1910 and, in Paris, Gutfreund witnessed the assembling of paintings by Matisse, Derain, Vlaminck, Friesz and Braque, though not Picasso.

In the company of Matějček, Gutfreund returned home to Prague in the early summer of 1910, travelling through France to London and thence through Belgium and Holland before visiting Cologne and Berlin, arriving back in July. Although he never saw the French Post-Impressionist paintings displayed in Prague, his direct contact with them, and the enthusiasm of Matějček made a deep impression. It was this experience that was the driving force behind Gutfreund's relief, *Brickmakers* (signed and dated 1911), rather than contemporary Czech sculpture. However, with growing confidence, Gutfreund had also, during his last months in Paris, begun to look more closely at Bourdelle's own sculptures, rather than listen to his teaching or the often rhetorical advice offered to his students. In retrospect it is clear that Bourdelle's high pyramidal or columnar figures, such as *Mélancholie* (1909) and *Beethoven drapé* (1910) (both Museé Bourdelle, Paris), clearly attracted his attention. The figure of *Mélancholie* is built up in broad planes, like an obelisk coming to a focus at the head, and this type of composition was very popular with Bourdelle during precisely the period Gutfreund was working with him. Indeed, in the small model of a woman in a long dress with her arms crossed, standing on a tapered rock form, executed in 1911 or shortly after (private collection, Dvůr Králové), the debt to Bourdelle is even more specific and points the way to the first major sculptures of Gutfreund's early maturity.

In the two standing figures *At the Mirror* and *Anxiety* (both 1911), Otto Gutfreund for the first time achieved a mature and highly distinctive personal style, and to the strong sense of structure learnt from Bourdelle he wedded a dramatic, facetted surface inspired by contemporary developments in French painting. The geometrical precision of these forms, defined by sharp, straight edges, is spiritually akin to the discipline governing the whole structure, and thus the restless planes with strong contrasts of light and shade do not undermine the architectonic coherence of the whole. However this was essentially a painterly approach, and in his two other sculptures of 1911 – *Hamlet* and *Don Quixote* – Gutfreund explored a different range of ideas. In the standing figure of *Hamlet* the material and the form are treated with much greater freedom and Bourdelle's

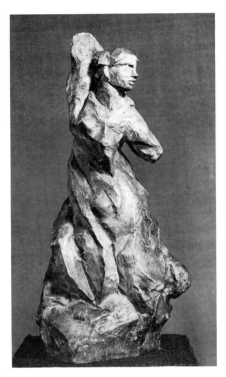

126. Otto Gutfreund
At the Mirror, 1911, bronze, 44.5 cm, signed

127. Otto Gutfreund
The Cellist, 1912, bronze, 47.5 cm.

128. Otto Gutfreund
Figures Embracing, 1912-13, bronze, 66 cm, unsigned

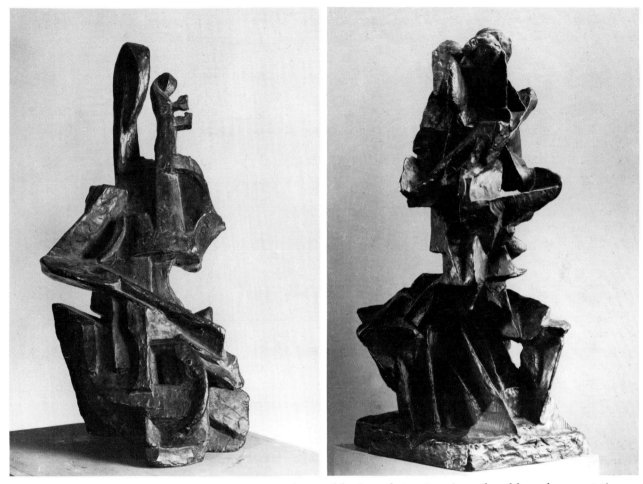

129. Otto Gutfreund
Don Quixote, 1911, bronze, 38 cm, signed

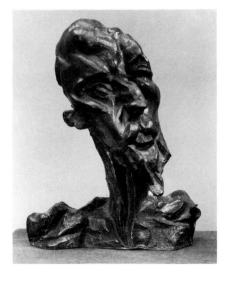

stress on internal logic and structure is replaced by a fragmentation which is much more Futurist than Cubist in character. Instead of the geometricising of forms so evident in *At the Mirror* and *Anxiety*, which, in their emphasis on the formal structure of the motif, approach Analytical Cubism, the straight linear edges of the facets are replaced by flowing, linear elements which are combined together to give an effect of movement. Gutfreund's expressively distorted head of *Don Quixote* follows a highly individual – but compromise – path between the Analytical Cubism of Picasso (for example in his *Woman's Head* of 1909) and the experiments of the Futurists. Although Umberto Boccioni did not turn to sculpture until the following year, Gutfreund's *Portrait of Father, IV* (relief, 1911) anticipates to an extraordinary degree Boccioni's sculptural language.

During the course of 1911 Gutfreund established himself firmly in Prague, acquiring his own studio in the Letná district of the city, and becoming a member of The Group of Artists. The latter brought him into intimate contact with the most avant-garde in Prague, but whilst the sculptures discussed above belong to his more experimental work – and in retrospect his most important at the time – Gutfreund also had to earn a living and so undertook a number of straightforward portrait commissions which were executed concurrently. These

130. Otto Gutfreund
Sitting Woman, 1917, wood, 74 cm

included his work on the portrait roundels for the Hlávka Bridge in
Prague, on which he collaborated with the architect Janák (1911-12:
Jan Štursa's work on the pylons was undertaken between 1912 and
1913). Nevertheless he pressed ahead with his experimental work,
And in 1912-13 firmly broke away from the influence of painting
with a series of dramatic small compositions which are fully Cubist in
their construction. In this process *The Cellist* and *Figures Embracing* are
landmarks, with the surface geometricisation of forms replaced by
dynamic structures in which the planes are carried right through the
composition and there is a new dynamic interaction between the
forms and space. Gutfreund himself recognised the point of contact
with the Baroque in an article in *Umělecký měsičník* (II, 1912-13, 9):
'The apparent similarity between Baroque and present-day sculpture
issues from the wealth of movement and the liveliness of form. In the
Baroque period this movement was given by the forces not being
balanced, by struggle; today we are endeavouring to develop action
freely without any signs of struggle. The struggle without a final
equilibration always bears signs of pathos, that is, struggle, an
expression of strength on the surface, not strength as such. It is not
strength disciplined in the service of an idea, but tension for the
independent dramatic effect of tension. '

Notwithstanding Gutfreund's wish to avoid Baroque forms of
struggle, it is precisely the elements of Baroque drama and dynamism
which set Gutfreund's Cubist sculptures apart from those of the Paris

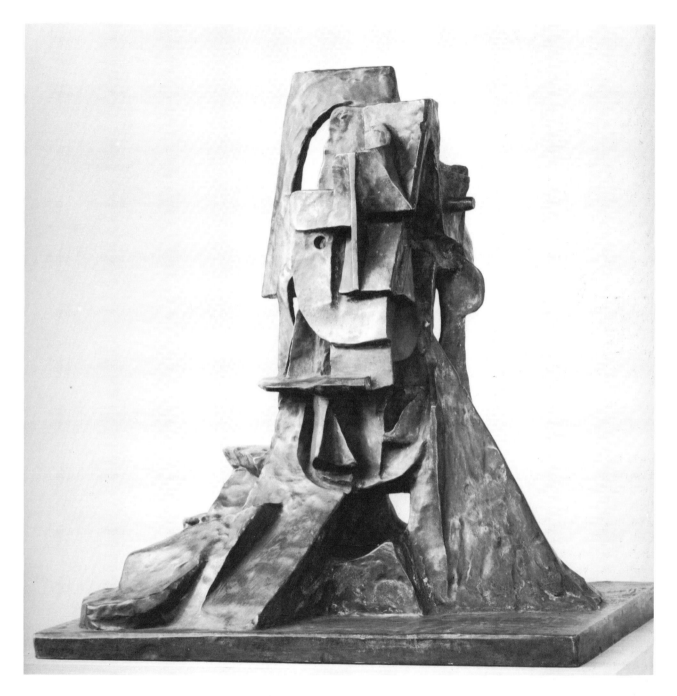

131. Otto Gutfreund
Cubist Bust, 1912-13, bronze, 74 cm

sculptors: the sophistication of his *Cubist Bust* (1912-13) is to all intents unparalleled there. However the stress on movement and expression, which was developed in *Hamlet* and *Don Quixote* also finds a new intensity in *Viki* (1912-13) and here the Cubist forms take on a flowing quality strongly reminiscent of the Futurist sculptures of Boccioni, though there does not seem to have been any contact between the two artists. The Group of Artists exhibited their work four times in Prague between 1912 and 1914, with other

exhibitions in Berlin and Munich (1913), and all the sculptures mentioned above were exhibited at least once during those group shows. However, in 1914 Gutfreund left for Paris with Emil Filla and his wife in order to work more closely with the new ideas being developed there. Prague, in 1911-14, had become an important centre for the avant-garde, with the brilliant flowering of Czech Cubism, which extended to architecture as well as painting and the decorative arts. But with the exception of occasional sculptural essays by Filla and Štursa, Gutfreund was working as a Cubist sculptor in almost total isolation, and he needed deeply the strength to be drawn from renewed contact with the Paris artistic community.

After the outbreak of the First World War Gutfreund volunteered for service in the French Foreign Legion, and as a member of the Nazdar Company saw active service in the trenches from November 1914 until December 1915. Highly intelligent, and somewhat anarchistic by temperament, Gutfreund's uncooperative response to military bureaucracy and discipline, together with his questioning attitude, led to his falling foul of the Czech officers commanding the company and he was interned from 1915 to 1918 in a camp in Provence for alleged incitement to rebellion. During this time the work that he had undertaken in Paris had been destroyed, and only two small wooden constructions survive from his years in internment. On his release in 1918 he settled again in Paris, and by working occasionally as an interpreter managed to scratch a living whilst returning to systematic creative work. In his Cubist compositions of 1919, Gutfreund turned away from the constructions executed by Picasso after 1912 and instead moved closer to the Synthetic Cubism of Juan Gris, in which the prime interest is the creation of an effective formal pattern, and the geometricisation of form is merely a means to this end. As before, Gutfreund's relationship to Cubism was both highly personal and unorthodox, but in his *Head of a Woman* (1919) the simplicity and clarity of the forms herald a change in his style.

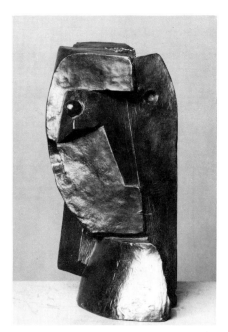

132. Otto Gutfreund
Head of a Woman, 1919, bronze, 27.5 cm

Emil Filla

Primarily a painter, and the principal theoretician of Czech Cubism, Emil Filla (1882-1953) was born in Chropyně, near Kroměřiž in Moravia, and studied at the Academy of Fine Arts, Prague, from 1903 to 1905. Afterwards he went on study trips to Germany, Holland, France and Italy (in 1906) and from 1907 to 1914 he visited France every year. Filla took up the Cubist style of painting, adapted to his own particular ideas, in about 1910, and remained true to those ideals for the rest of his life. In 1911 he founded The Group of Artists in Prague, which was dedicated to Cubism and organised exhibitions of members' work until its disintegration in 1914. Filla and his wife accompanied Gutfreund to Paris in 1914, and they were there at the outbreak of the First World War, when they left for Amsterdam. During their stay there Filla painted some of his finest

133. Emil Filla
Head, 1913, bronze relief,
32.5 x 24.5 cm

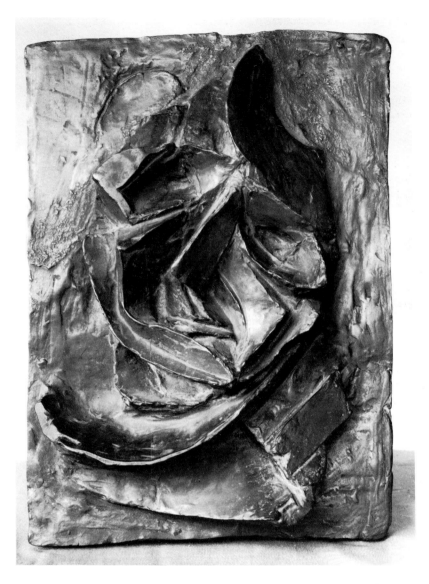

134. Emil Filla
Cubist Head, 1913, bronze,
130 cm, signed

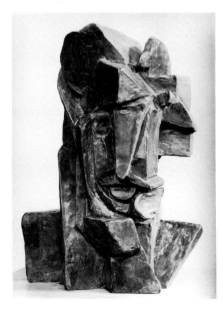

Cubist still-lives and threw himself into working for Czech
independence. His two sculptures, the bronze relief *Head* (1913) and
the bronze *Cubist Head* (1913-14), must be understood in the context
of his paintings, but they also provide a fascinating parallel to the
work of his close friend Gutfreund. The experimental nature of *Head*,
with its tentative translations of painterly forms into relief structures,
gives way in *Cubist Head* to a very forceful, if idiosyncratic, Cubist
composition in which the simple, block-like forms are assembled with
a robustness tinged with humour. Filla, from 1920 to 1939, again
made yearly trips to Paris and survived six years' imprisonment by
the Nazis to become Professor of Painting at the School of Decorative
Arts in Prague in 1945, but these two bronzes remain – apart from a
few models – his only essays in sculpture.

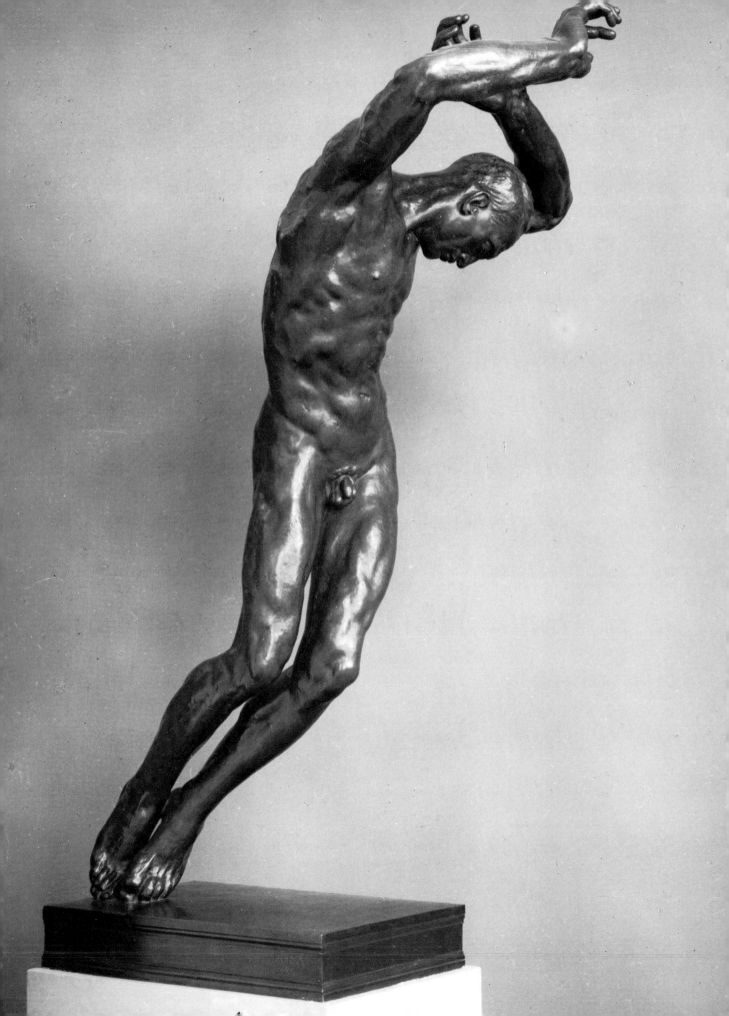

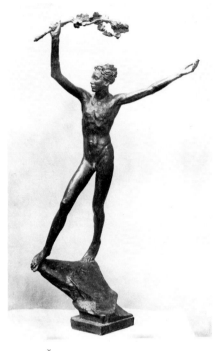

136. Jan Štursa
Victory, 1921, bronze, 130 cm, signed

137. Jan Štursa
Gift of Heaven and Earth, 1918, bronze, 202 cm, signed

135. Jan Štursa
Wounded, 1921, bronze, 201 cm, signed

Jan Štursa: 1917-1925

During the thirty months, from August 1914 to the end of 1916, that Štursa was in uniform, he spent long periods at the front as well as in reserve at Jihlava. Both experiences caused him acute mental and physical suffering, which he found difficult to accept, and his efforts to find a release in occasional sculptural work were largely ineffectual, and few works of any significance were created. On the other hand he made a great many drawings, both at the Carpathian front and in the rear, and his experiences on the battlefield transformed him as a man and an artist. The composition of his *Burial in the Carpathians* grew from these experiences and from a photograph of four soldiers burying a dead comrade. A quick drawing made in 1915 was transformed into a preliminary study which was cast in plaster in 1917 and carved in wood in 1918. The overall formal treatment, evoking a feeling of collective action and

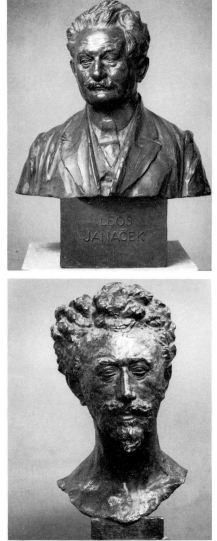

wartime comradeship in danger and in sorrow, is not dissimilar to a painting by Vincenc Beneš, *Military Burial*, also from 1915, and the two may share the same sources. In 1924 the sculptor enlarged the group and gave final forms to the details of the faces and draperies. This full-scale maquette for a monument to the fallen lacks the formal brevity and emotional impact of the original. A second sculpture, *Wounded*, had a similar genesis, from drawings made in 1916 and a photograph of the body of a young soldier hanging on the barbed wire. In Štursa's composition, such a soldier caught by a shot sinks to the ground, his hands for a moment helplessly flying above his head. In the 1916 drawing the figure of the wounded man is conceived as a nude without any specific details or narrative elements, in an endeavour to create a timeless symbol. The first version of the sculpture, 49.5 cm high, and with the composition fully evolved, dates from 1916, whilst in 1921 Štursa modelled the final version, 2 metres high, cast in bronze. Above any other inspired by the First

138. Jan Štursa
Portrait of Eduard Vojan, 1919, bronze, 71 cm, signed
National Theatre, Prague

139. Jan Štursa
Leoš Janáček, 1924, copperplated plaster, 74 cm, signed and dated

140. Jan Štursa
Max Švalinsky, 1918, bronze, 47 cm, signed

World War, this figure most fully expresses the response of Czech sculptors to the carnage of the war, and as such it occupies a very special place in the evolution of Czech sculpture.

At the end of 1916, on the recommendation of Myslbek, Jan Štursa was appointed head of the medals school at the Academy of Fine Arts in Prague, after the death of Sucharda. In consequence Štursa was released from military service and returned to Prague to undertake full-time teaching. The most important work he created during this period is the *Gift of Heaven and Earth* (bronze, 1918), representing a slim young girl with outstretched arms, holding a bunch of grapes in her left hand. Stylistically it marks a regression to his sculptures of 1908-10, but it has also been seen as an organic parallel to *Wounded*, as an ideological and artistic pendant – the two expressing the contradictory poles of the artist's interpretation of the world. In 1918, as the war came to an end in Central Europe, the new Czechoslovak Republic was established and Štursa won the competition for the *Monument to Svatopluk Čech* on which he worked systematically until 1923. The first two competition designs went back to Art Nouveau models, not uninfluenced by the recently unveiled *Monument to František Palacký* by Sucharda, while in the third design it is reduced to two figures. In developing this design the solid figure of the poet in everyday dress is contrasted with the floating figure of Genius, brandishing a branch of laurel over his head. Unlike the Sucharda composition, the figure of this world – the poet – and the figure of the world of imagination – Genius – are made of the same material (bronze) and thus there is a slight reduction in legibility. The figure of Genius was later reworked by Štursa, with a slightly modified form, as *Victory* (bronze, 1921) and in many respects this is a more successful composition than the monument, which was erected in Vinohrady, Prague, in 1924.

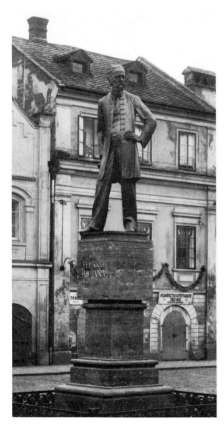

141. Jan Štursa
Bedřich Smetana, 1924, bronze, life size
Litomyšl

Jan Štursa: Portraits

One aspect of the public success achieved by Štursa, not least after 1919 when he succeeeded Myslbek as Professor of Sculpture at the Academy, was the large number of commissions for portraits he received in his last years. Whilst based at Jihlava he had executed a group of technically very competent but hardly inspired portraits, one exception being the *Portrait of the Fighter Pilot Mettl* whose unusual form of dress – the 'garb of a modern knight' – attracted the sculptor. Many of the others seem to resemble certain of the military types lampooned by Jaroslav Hašek in *The Good Soldier Schweik* and little, if anything, of the personality of the sitter is captured. However, in the *Portrait of Max Švabinský* (bronze, 1918) an entirely new dimension of psychological penetration is achieved. This breakthrough can perhaps be related to the fact that the sculptor and the sitter had been friends for many years and shared common artistic ideals. The rough surface of the bronze, which is such an important element in the liveliness of this portrait, is again exploited, together with very

tight modelling of the features, to great effect in the *Portrait of Eduard Vojan* (bronze, 1919), executed for the National Theatre in Prague. This bust possesses a dramatic presence, but the great Czech actor is depicted not so much as an individual but as a leading personality of the new Czech theatre, the representative of the heroes in Shakespeare's tragedies and comedies, and the interpreter of psychological doom in the dramas of Ibsen. On the other hand, the bronze preliminary sketch of 1919 is much looser, almost Impressionist in its handling as if in his search for expression the sculptor was at first exaggerating nervosity and trying to capture a fleeting moment. The finished bust is, in contrast, a timeless image.

In Štursa's later portraits, above all that of *Leoš Janaček* (bronze, 1924, made for the foyer of the Theatre in Brno), he adopted a much smoother treatment with broad painterly surfaces and the facial forms much more softly modelled. But the psychological penetration is greatly reduced and the three-quarter length figure of *Tomáš Masaryk* (1920-21), for example, is distressingly stylized. Commissioned by the newly-established republic, this portrait of its founding father lacks inner conviction and demonstrates only too clearly how much Štursa depended upon direct and extended contact with his model to give of his best. The excessive formality and coldness of *Tomáš Masaryk* could be forgiven in posthumous portraits such as that of *Svatopluk Čech*, though the full-length figure of *Bedřich Smetana* (bronze, 1924) in Litomyšl is a very successful essay in this genre. In his ability to depict heroes in monumental form there reappears in Štursa's work the influence of Myslbek's portraits and this late *rapprochement* with the work of the old master, after years of deliberate independence, has both internal and external reasons. In 1919 Štursa had taken over the School of Sculpture from him, leaving the headship of the medals school to Otakar Španiel, and in solving the compositional problems posed by monumental sculpture he himself also came to recognise how much he owed to Myslbek and his teaching. In particular he realised that the combination of qualities which he sought in portraiture had already, in a different mould, been achieved by Myslbek, and in consequence Štursa's late portraits reveal distinct parallels. Because of this double indebtedness to Myslbek he was the moving force behind the Myslbek exhibition mounted in 1922, intended to remind the public of the importance of his work, increasingly neglected as younger sculptors tended to occupy the stage. This coincided with the completion of the *Wenceslas Monument* and the death of the sculptor himself, so that Myslbek and his achievements were of general topical interest at the time.

Otto Gutfreund: 1919-21

Seen in isolation, Gutfreund's *Self-Portrait* of 1919, executed in coloured terracotta while he was in Paris, comes as a complete surprise and suggests a sudden stylistic volte-face. In this sculpture he displays a totally new objectivity and the simplification of the

142. Otto Gutfreund
The Spinner, 1921, glazed terracotta,
56 cm

143. Otto Gutfreund
The Printer, 1921, glazed terracotta,
56 cm

natural forms creates a strange atmosphere of heightened reality, whilst the use of colour increases the hieratical qualities of the head rather than its naturalism. How, then, did Gutfreund achieve this particular synthesis in 1919, and to what extent was he responding to external sources of inspiration? The use of colour was a particular preoccupation of Bourdelle in the years after the war (for example *La Jupe Plissée*, coloured terracotta, 1919, Musée Bourdelle, Paris) and there is a considerable resemblance between Gutfreund's slightly later *Portrait of Tána Bassova* (painted terracotta, 1920) and Bourdelle's life-size *Polychromed Head* (painted terracotta, 1921, Musé Bourdelle, Paris). However, Gutfreund's use of colour in the *Self-Portrait* is much more stylized and the question must arise as to possible contact with Elie Nadelman (1882-1946) who left Paris in 1914 and settled in the United States of America. Born in Warsaw but active in Paris from the beginning of the century, Nadelman geometricized natural forms in the pursuit of the perfectly proportioned nude. In 1914, shortly before his departure, a large exhibition of his work was held in Paris. His significance in the development of twentieth century sculpture has been consistently underestimated and his most influential period was that pre-1914. He began to paint his highly-stylized svelte wooden figures in 1917, and after his arrival in the U.S.A., but the closest parallel for Gutfreund's *Self-Portrait* is in Nadelman's work. It remains open whether the two artists' works are linked.

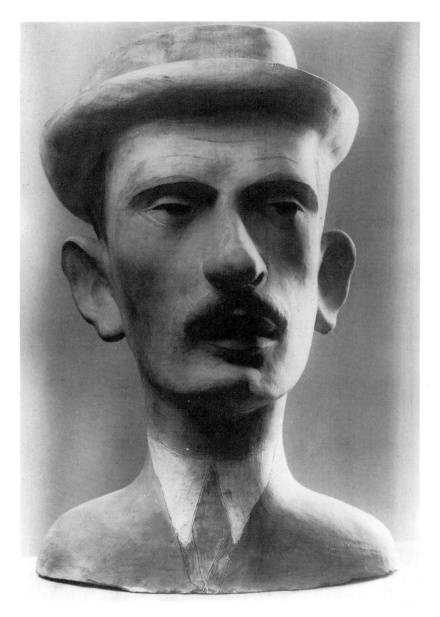

144. Otto Gutfreund
Self Portrait, 1919, coloured terracotta,
45 cm

145. Photograph of Otto Gutfreund, early
1920's

The Czechoslovak Republic had been established in 1918 and
Gutfreund was uncertain about the changed political and cultural
situation in Prague, but in June 1919 he arrived back on his first visit
since the end of the First World War, and settled in Prague again in
the following year. There he briefly shared a studio with Jan Lauda,
in the Holešovice area of the city, and in 1920 executed the painted
terracotta *Portrait of the Artists' Mother* which developed in style from
his *Self-Portrait*. The image, though insistently architectonic, does not
possess quite the hieratical formality of the latter, and the smooth,
schematic treatment of the hair points the way to Gutfreund's
sculptural style of the early 1920s. During the transitional phase
(1919-20) Gutfreund had also executed some small groups in painted
terracotta, including *Seaman with a Girl on his Lap* (c. 1919) and *Girl*

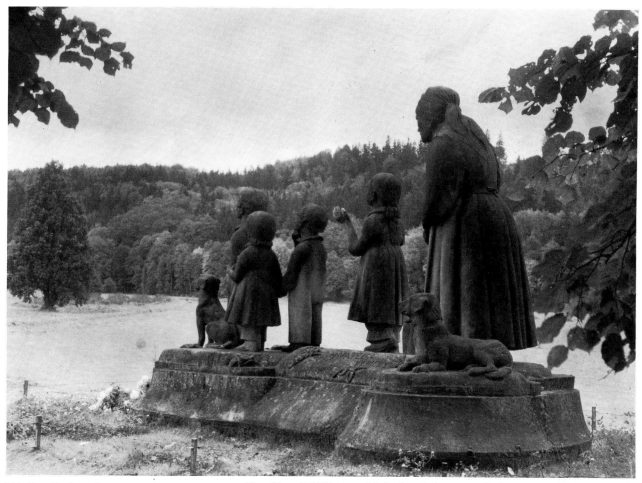

146. Otto Gutfreund
Monument to Božena Nemcová's grandmother at
Ratibořice, 1922, sandstone group, life size

with a Dog (1920), in which the Cubist vocabulary is treated in an
almost playful fashion, and the latter reveals such mixed motives as
to constitute a delightfully witty parody. Such subject matter was to
become of central importance to Gutfreund after he had settled again
permanently in Prague, and from this time onwards modelled clay
was to be his preferred medium. In this kind of subject – the life and
work of the common man – Gutfreund was to immerse himself,
whilst forging 'a new sculpture for a new country'. Of this
development the art historian V.V. Stech wrote: 'A feeling for the
existence of the "small man" grew up within him, a feeling for the
quiet and almost overlooked life close to the soil and growing like a
blade of grass among the paving stones. In brief, he, the former man
of elegance and exclusive formalism, became more human'. These
qualities are well-developed in his glazed, coloured terracotta groups
of *The Spinner* and *The Printer* (both 1921), and parallel with them is
the series of designs which he made for the *Monument to Božena
Nemcová's Grandmother*. The plaster maquettes, in three series, reveal
the evolution of this remarkable group, the old peasant woman and
four young children looking up in wonder. The final version was
carved the following year (1922) in sandstone and set up overlooking
a small meadow surrounded by forests at Ratibořice. However the

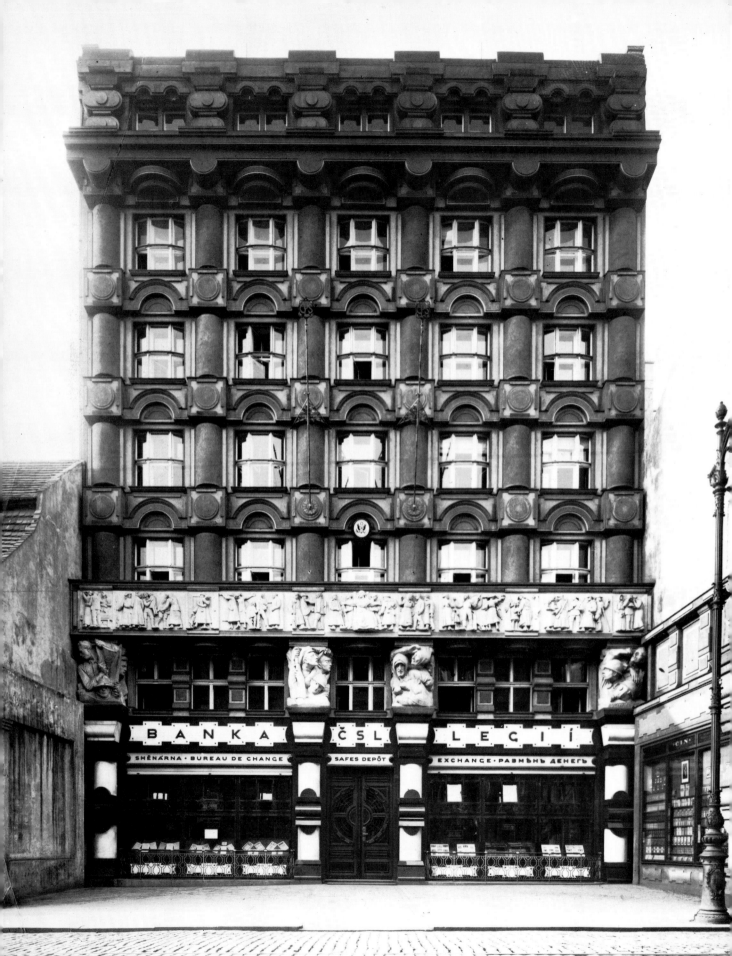

BANKA ČSL LEGII

SMĚNÁRNA · BUREAU DE CHANGE SAFES DEPÔT EXCHANGE · РАЗМѢНЪ ДЕНЕГЪ

18700

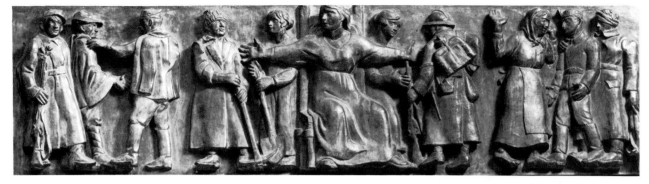

148. Otto Gutfreund
The Return of the Legionaries, 1921, bronze
Maquette for relief on the facade of the
Banka Legii

149. Jan Štursa
Vouziers, 1922-23, limestone
Decoration on the facade of the Banka
Legii

150. Jan Štursa
Doss'alto, 1922-23, limestone
Decoration on the facade of the Banka
Legii

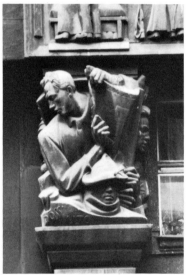

major work undertaken by Gutfreund at this time was the relief for
the facade of the Banka Legii in Prague (the designs were modelled
in 1921) and this sculptural complex was to prove one of the key
landmarks in twentieth century Czech sculpture.

The Decoration of the Banka Legii

Jan Štursa was invited to collaborate on the decoration of the
building of the Banka Legii (Bank of the Czechoslovak Legion) on
the Nar Pořici in the centre of Prague. Built to the designs of Josef
Gončár in 1922-23, the facade is strongly sculptural and in its
composition Gončár sought to integrate the sculpture and massive
architectural elements into a single organic mass. Štursa was
commissioned to execute the four great consoles which support the
continuous frieze sculpted by Gutfreund extending across the full
width of the building. They are in turn carried by the four broad
'pilaster' elements which articulate the ground and mezzanine floors.
In many respects this extraordinary building is remarkably
conservative, in that the clear separation of functions between the

147. Facade of the Banka Legii, 1922

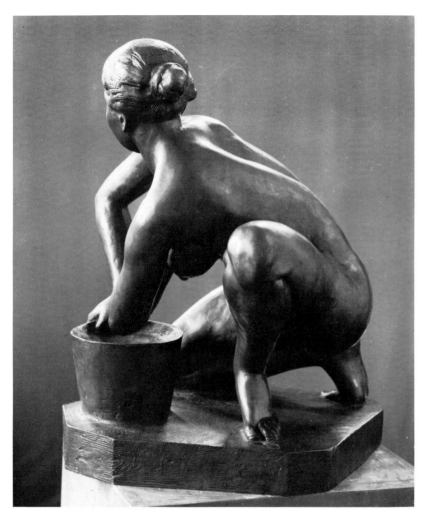

151. Jan Štursa
Girl washing, 1925, bronze, 76 cm, signed

152. Otto Gutfreund
Girl with a Rose, c. 1924, painted terracotta, life-size

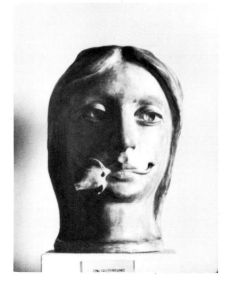

offices above and the bank below is that pioneered by Bramante in his Casa di Raffaello in Rome, and refined by Raphael himself in his Roman palaces. However, the disposition of the sculptural elements also indicates contacts with North Italian Renaissance models and a complete rejection of Central European Baroque and Neo-Classical palace designs. For the consoles Štursa carved half-length groups of military figures whose uniforms and equipment, reinforced by inscriptions, identify the four main areas in which Czech legionaries fought. The style of these sculptures was established by Otto Gutfreund in the relief above, which Štursa was content to follow in order to achieve the organic unity sought for the facade of the bulding: thus the Banka Legii console groups remain isolated in the oeuvre of Štursa whilst the relief by Gutfreund is not only one of his greatest masterpieces but also the key sculptural work for the generation of sculptors emerging in the early 1920s.

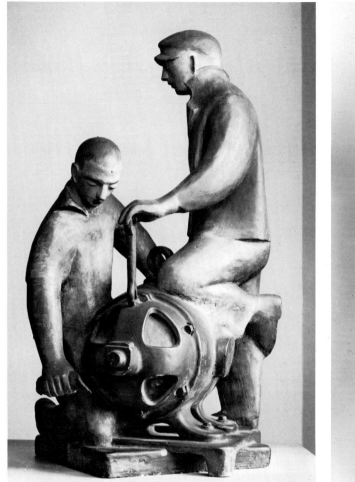

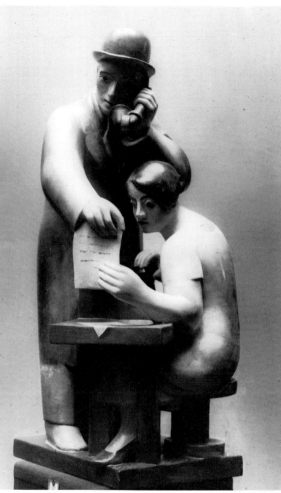

153. Otto Gutfreund
Industry, 1923, coloured wood, 76 cm

154. Otto Gutfreund
Commerce, 1923, coloured plaster, 75.5 cm

Jan Štursa: Last Works

Apart from the historical portraits of *Božena Nemcová* and *Marie Hübnerová* executed for the National Theatre in Prague, and that of *Leos Janáček* for Brno, already mentioned, the last sculpture executed by Štursa is the *Girl Washing her Breast* (bronze, 1925). This composition grew out of a chance observation made during work in the atelier and is the subject of a drawing (1923) though Štursa was probably not uninfluenced by classical marbles of the type of the kneeling Venus. The firm volumes and clarity of form separate this later nude figure from those of 1908-10 and although it clearly descends from the *Gift of Heaven and Earth* (1917-18), it shares much of the deliberate simplicity and directness sought by Gutfreund and others in their sculptures of the mid-1920s. Far from being isolated, Štursa in this last sculpture had returned again with authority to the centre of the stage, and his work stands by the side of the sculptures made by Gutfreund and the paintings of Rudolf Kremlicka. Meanwile Štursa was suffering from nervous depression and after weeks of treatment at Brno, which he wrongly believed to have been

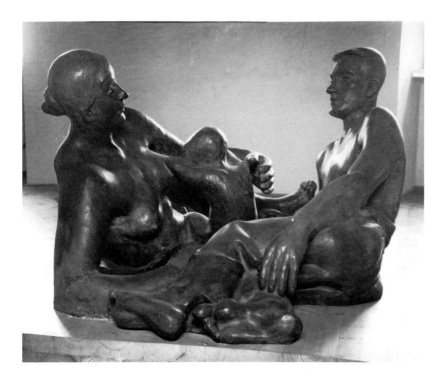

155. Otto Gutfreund
Family, 1925, bronze, 70 cm

unsuccessful, he became convinced that his physical and creative strength was being undermined. Consequently, on 28 April 1925, amidst his sculptures in the atelier at the Academy of Fine Arts, he shot himself, and lingering on, died 2 May of that year. Štursa's sudden and unexpected departure from the scene of Czech sculpture in the mid-1920s was only one of a series of blows. Although he left, in his most mature students – Břetislav Benda and Karel Dvořak (both of whom had also worked under Myslbek at the Academy) – those who fully comphrehended his later style, amongst his most faithful followers were to be Jan Lauda, Vincenc Makovksý and Josef Wagner. Like Myslbek before him, Jan Štursa was through his teaching and his work one of the seminal figures in the development of Czech sculpture.

156. Otto Gutfreund
Female nude, 1927, bronze, 125 cm.

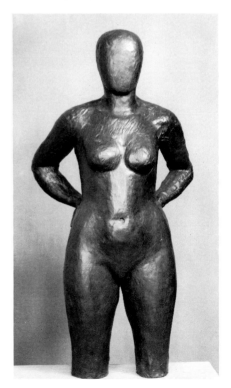

Otto Gutfreund: 1922-27

After the triumph of the decoration of the Banka Legii, Gutfreund continued to develop his Objective Realist style and in *Industry* (coloured wood, 1923) and *Commerce* (coloured plaster, 1923) he created two of the most powerful and intimate images in this phase of Czech sculpture. Meantime he continued to receive commissions for architectural sculpture, although he was becoming increasingly unsympathetic to its demands, and in 1924 he produced three sets of maquettes for the not entirely successful allegorical figures representing *Insurance, The Coffee House, Dance* and other subjects on the new Riunione Adriatica di Sicurtà building in Prague. Perhaps the most

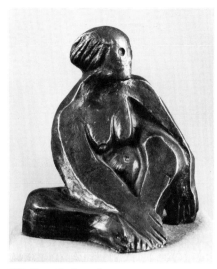

157. Otto Gutfreund
Seated woman, 1927, bronze, 23 cm

158. Otto Gutfreund
Seated woman II, 1927, bronze, 16.5 cm.

unusual of these commissioned works was the decoration on the
Škoda building in Prague (1927, now destroyed) which consisted of
an abstract design of wheels of different kinds with the Škoda symbol
superimposed, though such a design is foreshadowed in Gutfreund's
highly successful design of the Czechoslovak five-crown piece in
1925. In general Gutfreund was much happier working on life-size or
smaller sculptures, and in 1924-25 an almost wistful, romantic spirit
pervades his *Girl with Eye Lashes* and *Girl with a Rose* (both 1924)
whilst this is carried over into the life-size *Family* executed in the
following year. The deceptively simple composition of the latter
group, with the parents reclining in opposite directions thereby
creating an enclosure in which the young child tugs at the mother's
breast, is extraordinarily compact and the intensity of the relationship
of the parents, contemplating each other in mutual confidence, closes
the circle. Relationships between couples, of a more robust and
extrovert nature, are the key elements in a series of small groups of
this date including pairs of lovers and of brawling men.

As a portrait sculptor during the early 1920s, Gutfreund produced
several minor masterpieces, including those of *M. Gutfreundova* and *A.*

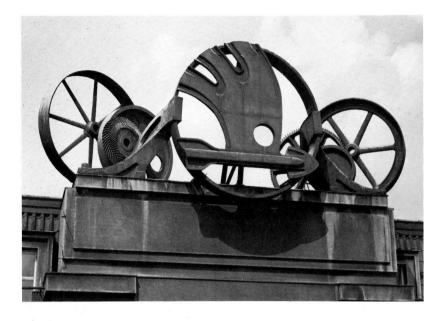

159. Otto Gutfreund
Bronze decoration for the Škoda building
in Prague, 1927. Destroyed

Kleinova (both 1923) but shortly before his appointment in 1926 as
Professor of Architectural Sculpture at the School of Decorative Arts
in Prague a new formality descended on his portraits, which is little
short of disastrous in his full-length figure of *Tomâš Masaryk* (plaster
1925, cast 1927). At this stage in his career one can detect a growing
lack of direction, as though Objective Realism had ceased to satisfy
him, and although he expended a great effort on his designs for the
Smetana Monument (1926) this complex ensemble of figures and
groups on separate plinths makes a nonsense of the Czech tradition
of scenographic monuments, as represented by Sucharda's *Palacký
Monument* and Šaloun's *Monument to Jan Hus*. Many of the individual
elements are of great quality but for an ensemble on this scale the
special qualities of Objective Realism are not entirely appropriate. No
doubt Gutfreund's recognition of that problem contributed to his
unease and his feeling that he had travelled far up an artistic cul-de-
sac. Consequently it is not without surprise that the critic finds
Gutfreund retracing his steps in 1927 and experimenting again with
the forms of Synthetic Cubism, but this was tragically cut short when,
on a particularly hot June day, Gutfreund impetuously dived into the
River Vltava near Shooter's Island in Prague and was drowned, at the
age of thirty-eight.

Otakar Španiel and Czech Medals

Mention has already been made of the importance of Stanislav
Sucharda's increasingly sophisticated relief style developed in his
small plaquettes from shortly after 1900, and until his early death in
1916 Sucharda, at the School of Decorative Arts in Prague from 1899
and as Head of the School of Medal Design at the Academy of Fine

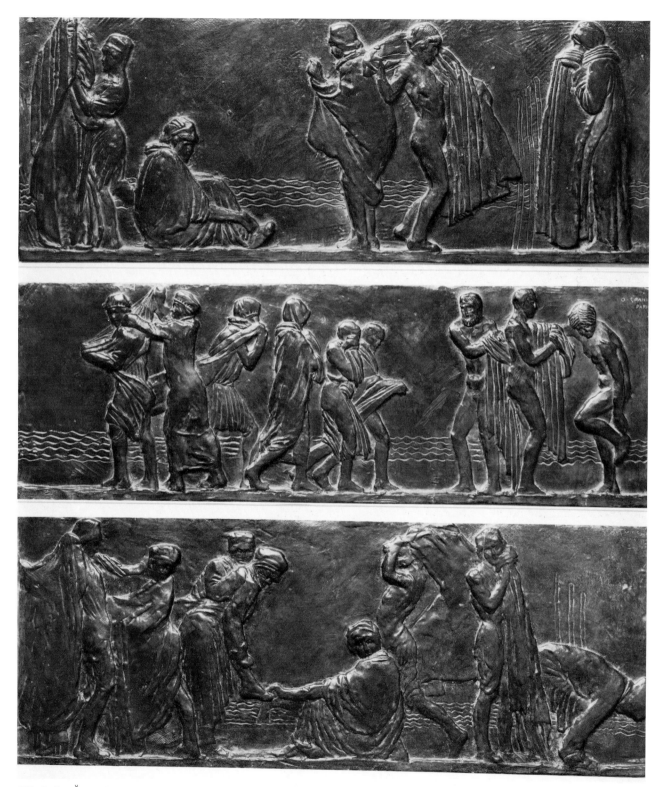

160. Otakar Španiel
At the Sea-side, 1908, tripartite bronze relief,
29 x 242 cm overall

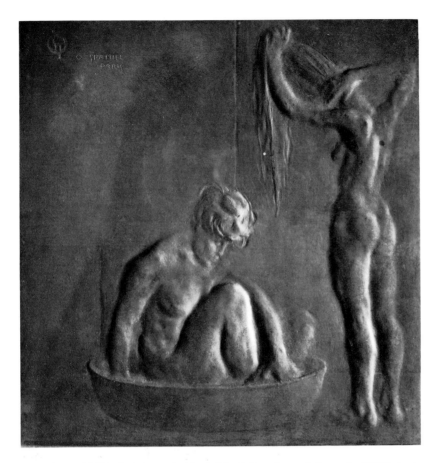

161. Otakar Španiel
In the Bath, 1908, bronze,
22.4 x 21 cm, signed

Arts from 1915, dominated this field of Czech sculpture. In 1919, just before his own retirement, Myslbek appointed to this vacant position Otakar Španiel (1881-1955) and thus ensured the continuity of this important element in Czech sculpture.

Born at Jaroměř on 13 June 1881, Španiel was first trained at the School of Engraving at Jablonec nad Nisou (1895-99) before turning to the field of medals and plaquettes. For this he undertook exhaustive studies and after two years at the Akademie der Bildende Kunste in Vienna under Josef Tautenhaym (1899-1901) he returned to Prague and the School of Sculpture of the Academy of Fine Arts under Myslbek till 1904. Myslbek recognised his great talents and encouraged Španiel to gain further experience in Paris where he remained for eight years. As might be expected from the strength of Art Nouveau ideas in Prague immediately after 1900, not least in the relief sculptures of Sucharda, Španiel's earliest plaquettes parallel those of Sucharda, but in Paris he cast, in 1907, a group of plaquettes representing sporting subjects – *Discus Thrower, Hurdler* and *Football Players* – which are remarkable for the freedom and directness of the modelling, with no trace of Art Nouveau preciousness. The following year Španiel produced in the pair of cast bronze plaquettes, *In the Bath* and *After the Bath*, intimate little gems of Impressionist modelling with a softness and delicacy which places them amongst the chefs d'oeuvre of early twentieth century Czech sculpture. However, in the

162. Otakar Španiel
After the Bath, 1908, bronze,
21 x 16 cm, signed

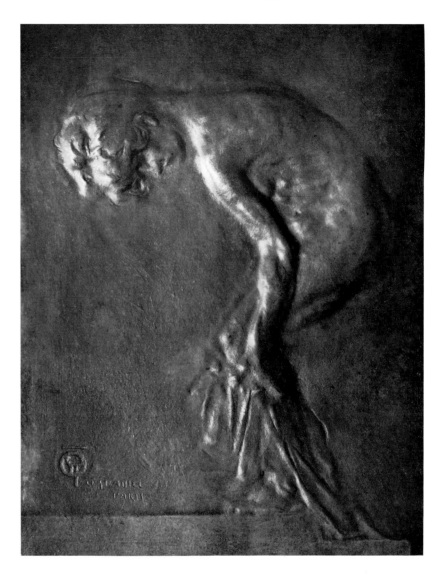

set of three bronze reliefs *At the Sea Side* (1908), executed on a considerably larger scale, a very different spirit prevails and the figures are sharply delineated.

In contrast to the atmospheric treatment of the backgrounds evident in the *Bath* plaquettes, the sea is indicated by stylised wavy lines, whilst the conscious classicism of many of the figures and the schematic multiple folds of the draperies suggest the impact of the ideas of Maillol and Bourdelle. However, in 1910, Otakar Španiel's work underwent another change when he turned instead to Renaissance medals and adopted the rigorous discipline of them as his models (for example, in *Václav Javůrek* and *Antonín Matějček*, both of 1910, and *Emanuel Chocholka*, 1911).

Španiel's talents as a portraitist were not confined to small scale reliefs and after his return to Prague in 1912 he executed a group of full-scale bronze portrait heads which echo the deep seriousness of

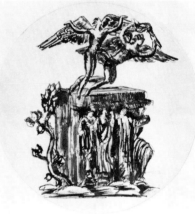

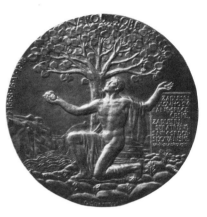

those of Myslbeck whilst exploiting a more broken surface. The *Portrait of the Painter, Herbert Masaryk* (1914) is almost uncomfortable in its grim intensity, but Španiel's *Portrait of the Poet, Ivo Vojnovič* (1918) is a brilliant, lively likeness with a wry twist to the lips. Executed in the same year, the medal commemorating the *Golden Jubilee of the Laying of the Foundation Stone of the National Theatre, in 1868*, reveals Španiel's characteristically cool and classicizing treatment and, on the reverse, the Renaissance triumph undertaken in modern clothes strikes a curious note of contrast to the obverse. In 1919, the year he moved from the School of Decorative Arts to the Academy, he received the commission for the medal commemorating the Liberation of the Charles University with the proud inscription on the obverse 'CONDITA MCCCCXLVIII – LIBERATA MCMXVIII'. The deliberate archaisms in the figures on the obverse accord well with the lettering, making up a tightly-packed square on the reverse, enclosing the medieval medal of Charles IV kneeling before St. Wenceslas. During the 1920s, the high quality of Španiel's portrait medals such as that of *Bedřich Smetana* (1924), was maintained, but in 1927 he received a highly prestigious commission requiring him to work on a vastly larger scale.

Work on the great Gothic Cathedral of Prague, St.Vitus, had been abandoned during the course of the sixteenth century and the completion of the building was one of the ambitions of Czech nationalists during the nineteenth century. The foundation stone of the West Front was laid in 1893 and work was eventually completed in 1929. However, to the last phase of that huge effort belonged the production of the massive bronze doors and the large reliefs above them. The four single-leaf doors are each decorated with four bronze reliefs depicting scenes from the history of the Cathedral and of Bohemia, and with the inverted T-shape of the reliefs above, form the shapes of broad crosses, though the two bronze doors to the sides of the central doors almost have the appearance of being unfinished. Assisted by V.H. Brunner, the reliefs for the doors were modelled by Španiel in 1928-29: their slightly self-conscious neo-medieval style is not entirely comfortable. This is evident in *Peter Parler directing work on the Cathedral*, on the right hand leaf of the central door, and the

163. Otakar Španiel
Commemorative medal for the liberation of Charles University, 1919, bronze, 95 mm diameter, signed

164. Otakar Španiel
Jubilee medal for the National Theatre, 1918, bronze, 76 mm diameter, signed

165. Otakar Španiel
Study for medal for Charles University, 1919, pencil

166. Otakar Španiel
The central bronze doors for St Vitus
Cathedral, 1928-29

167. Otakar Španiel
Peter Parler directing work on the Cathedral
Door panels of Main Door of West Front of
St Vitus Cathedral

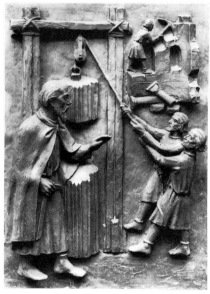

experiment was not repeated. For the remainder of his long career Španiel confined his attention to medals and teaching, but his immense authority over so many years was a mixed blessing, and, as with the unchanging style of the medals of Josef Šejnost (1878-1941) from 1912, this did not encourage innovations. Miloslav Beutler (1897-1964), one of Španiel's first and most talented students at the Academy, managed to exercise a limited degree of independence, and Jan Tomáš Fischer (1912-1957) did important work during the latter part of his career, but not till the 1950s did the range of Czech medals broaden substantially.

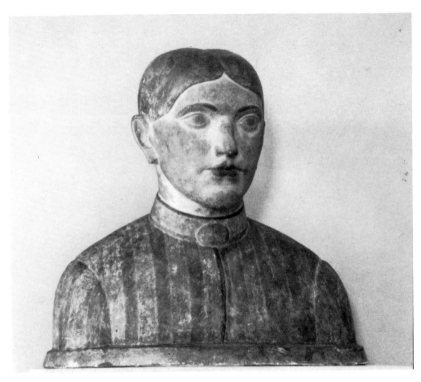

168. Josef Jiňkovský
Portrait of a Woman, 1921, coloured
terracotta, life size

Objective Realism and the Generation after the 'Return of the Legionaries'

Gutfreund's tragic death in 1926 suddenly robbed Czech sculpture of its leading protagonist, so it is useful at this point to summarise the situation. Of the older generation of sculptors, Myslbek – the grand old man of Czech sculpture and an artist of unrivalled authority –had died in 1922, whilst both Šaloun and Bilek were isolated figures, enveloped in their own dreams and with neither pupils nor followers. Sucharda had died, suddenly in 1916, and, of Myslbek's leading pupils, Kocián had withdrawn to teach at Hořice, dying there in 1928 at the early eage of 54. Štursa, Myslbek's successor at the Academy, committed suicide in 1925 and although Josef Mařatka continued to teach at the School of Decorative Arts until his death in 1937 his frigid academicism inspired few. After the First World War Bohumil Kafka was deeply involved in the production of the vast *Monument to Jan Žižka* and the example set by his *Orpheus* (1921) provided little of interest to the generation of sculptors born in the 1890s whose training had, so often, been rudely interrupted by the war years. The long-term influence of Myslbek in fact strengthened greatly from the last years of his life, as Impressionism was rejected in favour of the strong sculptural forms advocated by him, and the brilliant Cubist experiments of Gutfreund found no followers in Bohemia. Even Gutfreund himself felt Cubism to be an intellectually absorbing pursuit, but that the style was unintelligible to ordinary people. Consequently, in the *Return of the Legionaries*, he created a major sculptural complex in which his ideas of Objective Realism

169. Bedrich Stafan
Girl drinking Grenadine, 1924, coloured
terracotta, 42 cm

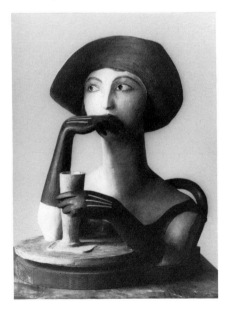

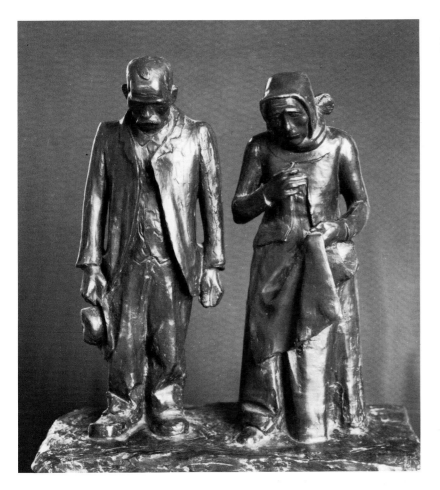

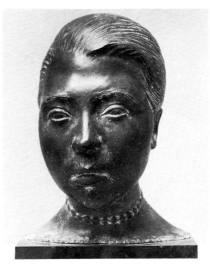

170. Karel Pokorný
Memorial to the Entombed Miners, 1925,
bronze, 58 cm

171. Jan Lauda
Head of a Girl, 1927, bronze, 32 cm, signed
and dated

172. Karel Pokorný
Earth, 1925, bronze, 68 cm, signed

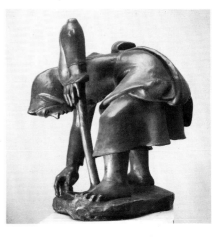

crystallised and which offered the coming generation a new set of stylistic and intellectual criteria in accordance with the social and political aspirations of the 1920s.

The parallelism with the Neue-Sachlikeit in Germany is obvious but, in company with other movements towards Realism developed in various European countries between the wars, Czech Objective Realism was a Czech response to the Czech socio-cultural situation in the 1920s and thus, although of European significance for the quality of the sculpture created (unmatched in the remainder of Europe), it can only be assessed within a Czech context. The elation which followed the creation of the new nation in 1918 was, by the mid-1920s, replaced by a realisation of the enormous problems facing it, with the constant spectre of the catastrophic inflation which had all but destroyed the social structures of Germany and Austria. Internal political and economic problems, later aggravated by the Wall Street Crash and the Depression, were to be the constant background for much of the 1920s and 1930s. In his choice of subject matter – the everyday lives of ordinary people – Gutfreund had revealed a great sensitivity to their current preoccupations, a sensitivity neither encouraged by the messianic qualities of Myslbek nor the detachment

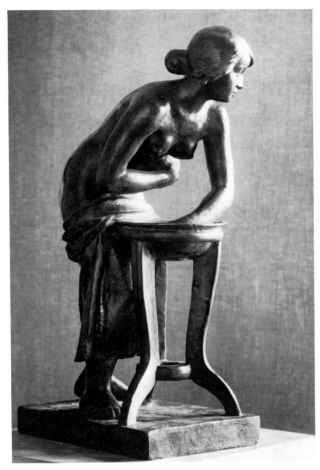

173. Břetislav Benda
Toilet, 1924, bronze, 51 cm, signed

174. Břetislav Benda
Girl lost in Thought, 1925, bronze, 52.5 cm, signed and dated

of most of his older pupils, although Stursa had briefly responded with horror to the carnage of the First World War. People did not wish to be reminded of the war and, in their preoccupation with the present, Objective Realism struck a very responsive chord. However, at least in the choice of subjects and a humble approach to them, the new style is to a certain extent prefigured by the sculptures of František Úprka who, from the late 1890s, had dedicated himself to portraying the simple lives of Moravian peasants with much of the directness and objectivity now sought by the new generation. The death of Gutfreund might have left Czech sculpture leaderless, and no other dominant personality of such stature emerged during the following decades, but such was the vitality and strength of the example which he left that it provided the central thrust of Czech sculpture almost until the end of the 1920s.

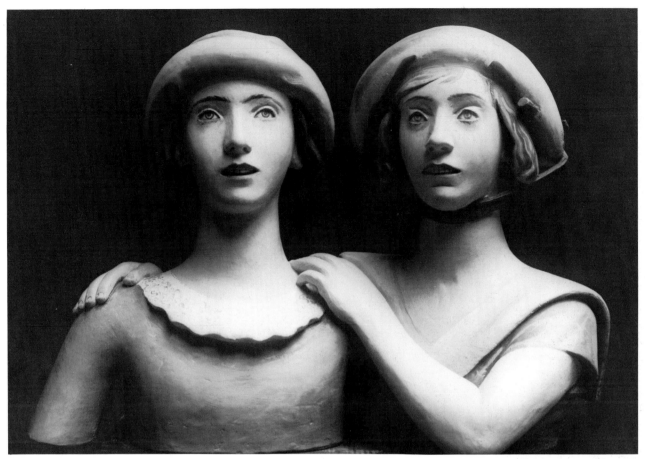

175. Karel Dvořák
The Girl Friends, 1924, coloured terracotta,
45 cm, signed and dated

Josef Jiřikovský and the early works of Bedřich Stefan

Not unsurprisingly, the earliest response to Gutfreund's sculptures of the early 1920s came from those closest to him, and, in *Portrait of a Woman* (1921), Josef Jiřikovský (1892-1950) reveals many of the detached, hieratical qualities which characterised Gutfreund's *Portrait of the Artist's Mother*, though in the surface treatment it is closer to Gutfreund's *Portrait of Tána Bassova* (1920). Nevertheless, whilst in his earlier painted terracotta portraits, Gutfreund preferred to cut off his model across the top of the shoulders, Jiřikovský adopted for his portrait a much lower cut-off, recalling later fifteenth-century Florentine terracotta portraits of this type. Gutfreund himself adopted this pattern for his *Portrait of A. Kleinova* (1923) and would have been familiar with the Renaissance models. However, in his *Dressmaker* (painted terracotta, 1920), Gutfreund created an intimate, full-length, seated figure some 45 cm. high which in its simple, rounded forms and use of colour is perhaps more closely related to the world of ceramics than to sculpture. Indeed this leads on to his *Spinner* and *Printer* (both 1921), which are painted and glazed as ceramics, but in the *Dressmaker* and the later figures a glazed surface was rejected in favour of the greater realism provided by a dry painted surface. Once

113

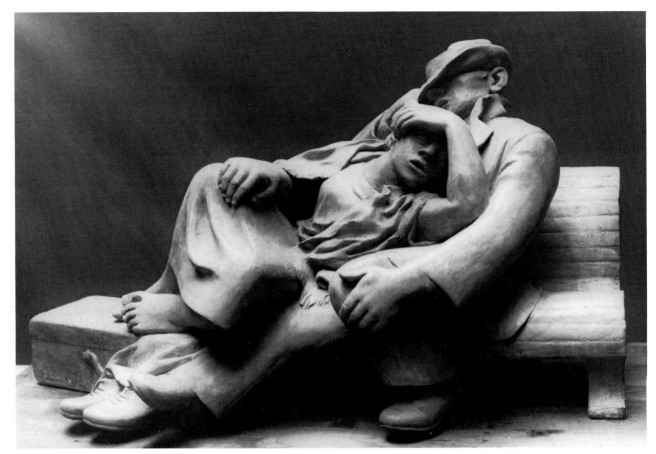

again Jiřikovský was apparently the first to develop these ideas, in his exquisite *Toilet* (1923) and this type of small full-length figure was to be very popular for the sculptors exploring Objective Realism.

Also in the forefront of the development of Objective Realism was Gutfreund's assistant, Bedřich Stefan (1896-1982). Born in Prague and a student of Kafka in the School of Decorative Arts there in 1914-17, he was called up for military service until 1919 before he could start his studies at the Academy. When he returned Štursa had taken over from Myslbek. On graduating in 1923 he became Gutfreund's assistant and his significance as a sculptor lies mainly in his contributions to Objective Realism. His *Girl drinking Grenadine* (coloured terracotta, 1924) is, in its svelte elegance and telling use of black for all the clothes, one of the most arresting images of the period and justly well known, but there is nevertheless a slight brittleness and superficiality evident and after his stays in France in 1925 and 1926 his attitude to Gutfreund's sculpture changed.

176. Karel Dvořák
To America, 1925, terracotta, 54.5 cm, signed and dated

177. K. Kotrba
Seated girl, 1926, terracotta

178. Karel Dvořák
Decoration for the former School of
Commerce, 1925, Prague

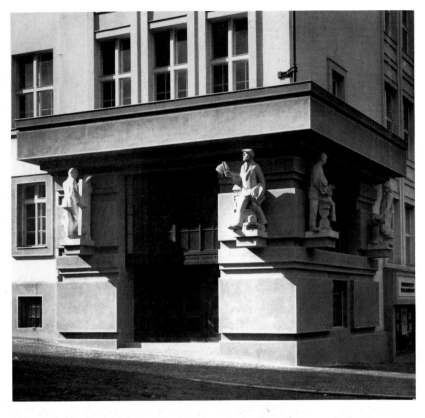

179. Karel Dvořák
Portrait of Miloslav Holeho, 1924,
coloured terracotta, life size

Karel Pokorný

Unlike his slightly younger contemporaries, Karel Pokorný (1891-1962) came deeply under the influence of Myslbek, and compared to the sculptures executed in the mid-1920s by the other members of his generation, his are distinguished by their deep seriousness and monumentality. Born in Pavlice, in Southern Moravia, Pokorný at first studied in the School of Blacksmithery at Hradec Králové (1910-11) after training in this field as a young man in Vienna (1905), working there and at Alzgersdorf afterwards. He came to Prague in 1911, to study under Josef Drahoňovsky at the School of Decorative Arts until 1914 and then graduated to the Academy to study under Myslbek until 1917. However he continued to study in Myslbek's atelier until the latter's death in 1922 and was consquently heavily involved in the completion of the *Wenceslas Monument*, above all the figure of St. Vojtěch which was set up in 1924. It was, no doubt, Myslbek who encouraged Pokorný to travel again and in 1923 that he went to Italy, though it was not until 1928 that he went to Paris. His relief, *The Bread Queue* (1916), apart from its topicality as a subject during the First World War, is executed in a style heavily indebted to Myslbek, though the seriousness which it displays grew out of his own personal convictions. These qualities are very highly developed in his stooping figure of an old peasant woman with a hoe, entitled *Earth* (bronze, 1925), which echoes the earlier sculptures of his fellow Moravian, František Úprka. Nevertheless, with its soft folds and sharp

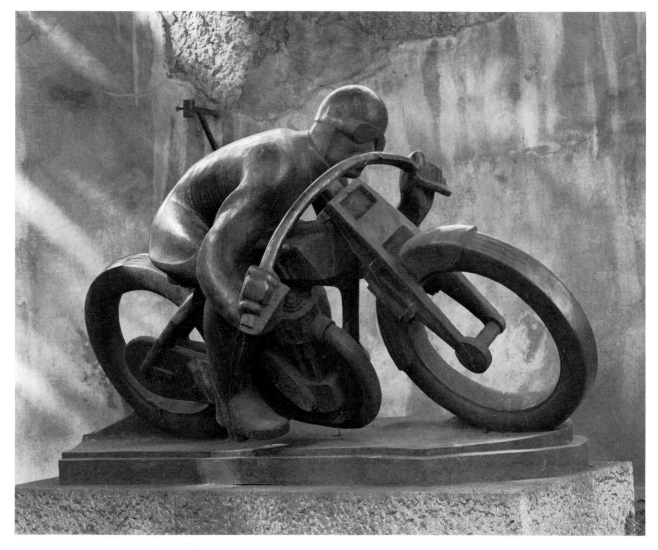

180. Otakar Švec
The Motorcyclist (Sunbeam), 1924, bronze,
114 cm.

focus, Pokorný's figure represents an important facet of Czech
Objective Realism, one which reaches a climax that year in his deeply
moving study for a *Memorial to Entombed Miners* (bronze, 1925).
Originally designed in 1925 for Láza near Orlov, the full-scale version
was set up to commemorate a mining disaster at the Nelson Colliery
at Osek near Duchov in North-Western Bohemia in 1934. In 1936
Pokorný was appointed Professor of 'Modelled Art' in the Technical
High School in Prague, where he worked until 1945 when he went
to teach at the Academy of Fine Arts until his death in 1962.

Jan Lauda

Very close to the beginnings of Objective Realism and the work of
Otto Gutfreund is the work of Jan Lauda (1898-1959) dating from the
mid-1920s. A native of Prague he studied at the School of Decorative
Arts from 1913 to 1916 and then, after war service, under Štursa at
the Academy until 1922. His life-size bronze *Standing Girl* (1921)
owes much to Štursa, particularly in the modelling of the sturdy legs,
and the sharp focus on the imaturity of the model recalls Štursa's
own early works, not least *Puberty* (1905). Lauda's principal work of
the mid-1920s, his *Woman Scrubbing the Floor* (1923) is, however, an
uncompromising essay in the style of Objective Realism and it was
Štursa who encouraged Lauda to scale up his small model into an
almost life-size sculpture. Part of the emotional freshness and
directness of sculptures such as *The Potter* (terracotta, 1923) can be
traced to Štursa, but the intimacy of form and initial inspiration stems
from Gutfreund. Unfortunately these qualities in his terracotta
sculptures of 1922-23 were very soon lost, since they did not transfer
successfully to larger-scale formal sculptures, and although Lauda
executed a number of distinguished portrait heads his later work is of
relatively little significance. His wistful *Head of a Girl* (painted plaster,
1927, with later casts in bronze) documents the renewed strength of
Štursa's influence which characterises much of Lauda's later work.

181. Bedřich Stefan
Nude girl with her hands behind her head,
1926-27, bronze, 60 cm

182. Bedřich Stefan
Seated woman II, 1930,. bronze, 56 cm.

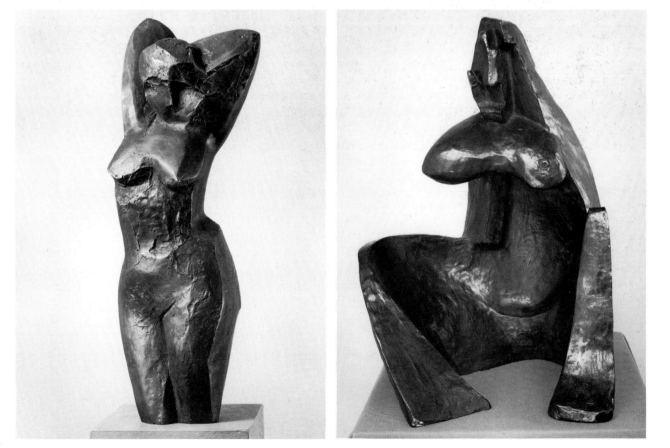

After the Second World War he taught at the School of Decorative Arts, until his appointment as Professor at the Academy of Fine Arts from 1946 to 1959.

Břetislav Benda

In many respects the development of Břetislav Benda (born 1897) closely parallels that of Jan Lauda, who was only thirteen months younger. Born at Lišnice, near Milevsko, Benda was first trained under Quido Kocián at the School for Sculptors and Stone Masons at Hořice from 1911 to 1915. He was fortunate in not being called up and went straight into the Sculpture School of the Academy in Prague where he studied under Myslbek, and, under Štursa, from 1919 to 1922. During this time he made study journeys to Dresden and Vienna in 1921, but in his earliest independent scuptures of significance – such as the heroic half-length *Peasant Girl* (bronze, 1921) the influence remained overwhelmingly that of Jan Štursa. Also from 1921 dates his *Young Girl tying a Scarf around her Head*, of which Benda also modelled a life-size version, and this is closely related to Štursa's *Gift of Heaven and Earth* (1918), the same model having been used by Štursa for his preliminary drawings, although in his final sculpture the forms are much fuller. Benda's retention of the model's rather skinny forms is indicative of his desire to represent his model as truthfully as possible, and although a strong element derived from Štursa runs through his sculpture of the mid-1920s the synthesis achieved in *Toilet* (1924) and *Girl lost in Thought* (1925) owes much to the demands of Objective Realism. These small bronze figures are amongst the most lyrical creations of Czech sculpture of the period and Benda, with varying degrees of success, continued working in this vein for much of the decade. The terracotta *Man straightening a Scythe* (1927-28) is amongst the last of Benda's sculptures with the particular flavour of Objective Realism and subsequently he leaned increasingly towards the examples set by Štursa. Study journeys to France in 1923, 1924, 1932 and 1937, Italy in 1924 and Greece in 1936 had a limited impact on his style and for much of the 1930s and early 1940s it could he said without prejudice that in Benda had been reborn the spirit of Štursa.

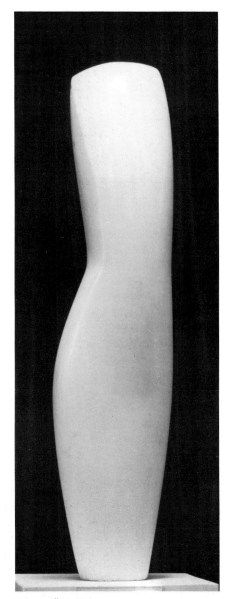

183. Bedřich Stefan
Torso III, 1929, marble, 81.5 cm.

Karel Dvořák

Although some five years older than Lauda and Benda, the career of Karel Dvořák (1893-1950) closely parallels theirs and during the 1920s he oscillated between a strong lyricism derived from Štursa and the Objective Realism stemming from Gutfreund. A native of Prague, Dvořák was a pupil of Josef Drahoňovský at the School of Decorative Arts from 1911 before entering the Academy in 1913. After one year there under Myslbek he was called up for military

184. Zdeněk Pešánek
Monument to modern traffic, 1926
Destroyed

185. Zdeněk Pešánek
Monuments to the Pilots who died for Prague,
1924-26

service and returned in 1917 to study under, at first, Myslbek and for the last months Štursa. Nevertheless, by the middle of the 1920s, he had seized fully the opportunities presented by Objective Realism, and much of his finest work is concentrated into 1921-25. His intriguing *Girl Friends* (painted terracotta, signed and dated 1924) may well have been inspired by Bedřich Stefan's *Girl drinking Grenadine* (1924) and it shares the same slightly arch quality. Nevertheless it is one of the most characteristic images of Czech Objective Realism and quite clearly there was amongst this group of sculptors a lively competitive spirit at this moment with, in consequence, a rapid exchange and development of ideas. Equally telling is the imagery of his pair of foot-sore emigrants on a bench, *To America* (red painted terracotta, signed and dated 1925), though it is revealing to note that despite the choice of material, subject and treatment the face of the young woman is a typical of Štursa. However, also in 1925, Dvořák was also called upon to undertake the figure decoration around the entrance of the (former) School of Commerce in Prague, for which he executed four lively full-length figures in contemporary dress. This was a year of intense activity, with similar figures, representing *Perils on Land and Sea*, flanking the entrance of the Lloyd Adriatica Building on which Gutfreund was also working, and the decoration of the front part of the arcade at Pardubice. Soon afterwards, in sculptures such as his *Fourteen-Year-Old Girl* in the Kinsky Gardens in Prague (1928) the influence of Štursa greatly strengthens, although as late as 1930 and the wood carving *Country Girl* there is a sharpness of vision and clarity of forms which owes much more to Objective Realism than to Štursa's lyrical treatment of the female nude. Dvořák was close to Gutfreund and after his tragic death by drowning it was Dvořák who made the bust

of the sculptor to be placed on his grave in the Vinohrady Cemetery.

Comparable to the problems experienced by Španiel with the Cathedral doors, the commission for the over-life-size sandstone group of *St. Cyril and Methodius* on the Charles Bridge very clearly strained his resources. Executed in 1928-38 it presents an extraordinary amalgam of stylistic elements, with echoes even of Bilek and Šaloun, and it would seem that the sculptor was seriously overawed by the site. Dvořák taught at the School of Decorative Arts from 1928 until 1950 and it was into this work that much of his later energy was directed.

Karel Kotrba

Amongst the generation of sculptors who subscribed to the ideas of Objective Realism, Karel Kotrba (1893-1938) occupies an exceptional position. Trained at first in the School of Decorative Arts between 1912 and 1913, he returned to Prague after the First World War and enrolled in the School of Medal Design at the Academy where he studied under Španiel until 1923. However he became increasingly concerned with theoretical and social issues in the mid-1920s, and joined with a group of painters in issuing a manifesto proclaiming a programme of social art. His small plaster figure of a *Dressmaker* at her treadle sewing machine (1923) is a relatively early contribution to the genre of Objective Realist sculpture, but the determination with which Kotrba minimises the sensual qualities of the clay model, from which the cast has been made, is revealing. This compactness and economy in the handling is unlike the other small figures with which it forms a group and reflects Kotrba's intellectual stance. His polychromed terracotta bust-length *Portrait of Miloslav Holý* (1924) is much closer in spirit to those of Gutfreund, in part due to the hieratical quality sought in varying degrees in all the portraits in this group. But in his later small figure, *Seated Girl* (terracotta, 1926 and later casts in bronze), the intentional indifference to the beauty of the body and face is both pronounced and typical of Kotrba's nudes of the time. In 1927-28 the sculptor studied privately in Paris and parted company with the already weakened tradition of Objective Realism in Prague, and his *Woman's Torso* (bronze, 1932) instead reveals his response to Despiau, Wlérick and French sculpture of the period.

186. H. Wichterlova
Wonder, 1923, bronze, 156 cm

187. H. Wichterlova
composition, 1929-30, bronze, 70 cm

Otakar Švec

A native of Prague and a pupil of Josef Drahoňovský at the School of Decorative Arts there from 1907 to 1911, the training which Otakar Švec (1892-1955) received at the Academy was again interrupted by the First World War. At first he studied under Myslbek, from 1912 to 1914 and on his return in 1916 under the elderly master, with the last months under Štursa. During the early 1920s he produced some polychromed sculptures, inspired by Gutfreund, which belong to the tradition of Czech Objective Realism, but his masterpiece was undoubtedly his *Motorcyclist* (bronze, 1924). This almost life-size sculpture triumphantly evokes the exhilaration and spiritual uplift achieved by the rider of a racing motorcycle at speed. In his interest in the shapes of modern technology and the popular love of sport,

Švec brought together in this sculpture several strands rarely explored by the other sculptors in the group. After the suicide of Štursa in 1925, Švec succeeded him for some twelve months as Professor at the Academy, but his later career was less happy and having, many years later, accepted the commission to undertake the huge *Monument to Joseph Stalin* for Prague, he himself committed suicide shortly before it was unveiled.

Diversification: Bedřich Stefan, 1926-30

Towards the end of the 1920s Objective Realism and the sculptural traditions established by Gutfreund began to break up and the sculptors subscribing to its ideas developed new lines of investigation. As we have seen earlier, the posthumous authority of Štursa if anything grew, particularly through the sculpture of Břetislav Benda and Jan Lauda, but it was Gutfreund's former assitant, Bedřich Stefan, who was in the vanguard of the diversification which characterized the 1930s. After his return from his second visit to Paris in 1926, Stefan turned again to Gutfreund's sculpture, but instead of concentrating on the corpus of Objective Realist sculpture, looked instead at the ideas he was developing just before his death. Stefan's *Nude Girl with her Hands behind her Head* (bronze 1927) is quite clearly based on Gutfreund's sculpture of the same subject in plaster, also 1927, but in contrast to the calculated, almost geometrical flowing curves of the Gutfreund figure, Stefan cuts away the plaster into broad planes, in a manner which suggests a knowledge of Matisse's bronzes, such as the *Grand Nu Assis* (1922/25). Equally clear is the derivation of Stefan's *Seated Woman II* (bronze, 1930) from Gutfreund's very late *Study of a Seated Woman II* (plaster, 1927) in which he began to retrace his steps to the Synthetic Cubism which he had briefly explored in 1919. This experimental approach was very unusual in Czech sculpture during the 1930s, notwithstanding the highly imaginative experimental pieces by Zdeněk Pešánek which are occasionally reminiscent of Russian experiments during the early 1920s. In his series of *Torsos* Stefan first led Czech sculpture into pure abstraction. *Torso III* (white marble, 1929) took as its cue the carvings of Brancusi, but not long afterwards Stefan renounced such speculations and in his marble relief for the interior of the Lipa Insurance Company Building in Prague (after 1936) and his *Mother and Child* (marble, 1937-38, now at Zbraslav) the orthodox figurative style is fully in the tradition of Štursa. Bedřich Stefan subsequently taught at the School of Decorative Arts in Prague from 1940 until 1958, and his work after the early 1930s is relatively unimportant within the development of Czech sculpture. However the ideas which he initiated were seized upon eagerly by the generation of sculptors born in 1900-1903.

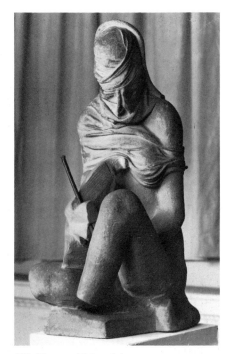

188. Vincenc Makovský
Girl with a child, 1935, stone

189. Vincenc Makovský
Design for a turret lathe MAS R, 1942, plaster, life-size
Municipal Art Gallery, Gottwaldov

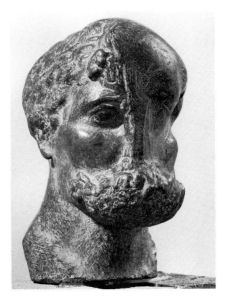

190. Vincenc Makovský
Head of Prometheus, 1934, granite

Born at Prostějov and a pupil of Jakub Obrovský and Jan Štursa at the Academy in Prague (1919-25), Hana Wichterlová (born 1903) is the sole surviving Czech sculptor of importance who was active in the 1920s and 1930s. She was fortunate in that her training was unaffected by the war years and thus she found herself, in the 1920s, in the same stage of artistic development as many others almost ten yers older. However, despite her very limited activity, she was a sculptress of some distinction during much of the inter-war period and her full-length figure of a young girl, hands raised and gazing upwards, as if to catch a butterfly, entitled *Wonder* (bronze, 1923) was executed whilst she was a student at the Academy. In both type and handling the figure is within the tradition established by Štursa, and of remarkable sensitivity and mastery for a twenty-year-old student. After completing her studies at the Academy, Hana Wichterlová made an extended study trip to France, from 1926 to 1929, and returned to Prague at the moment when the strength of Objective Realism was almost exhausted. However, from Paris she brought her recent experiences of French abstract sculpture and these are reflected in her *Composition* (bronze, 1929-30) which takes its place with the contributions made by Bedřich Stefan to the renewed spirit of lively experimentation charactertistic of Prague in about 1930.

Vincenc Makovský

Like Štursa, a native of Nové Město na Morave in south-western Moravia, the sculptor Vincenc Makovský (1900-1966) also struck out early in the direction of abstraction. At the Academy in Prague, he first studied in the painting class of Krattner (1921-22), before transferring to the Sculpture School under Štursa (until his death in 1925), and he completed his formal training at the Academy under Bohumil Kafka (1925-26). He had visited France in 1925 and in the following year he returned for an extended stay in Paris till 1930, with the first year spent in the studio of Antoine Bourdelle, supported by a French Government bursary. Makovský returned to Prague in 1930, having experimented during his years in Paris with a wide range of figurative and abstract ideas, including his own interpretations of Cubist and Constructivist forms, and the first half of the 1930s saw a strengthening of the imaginative elements and a movement towards Surrealism in his work. The Cubist fragmentation of Makovský's *Reclining Woman* (1929-30), executed in Paris, may be set alongside the powerful imagery of *Head of a Horse* (bronze, 1931), with its abstract forms derived from natural shapes, and the composition of the aptly named *Girl's Dream* (bronze, 1931). Makovský was one of the founders of the Prague Group of Surrealists but his adherence to Surrealism – for example in *Head of Prometheus* (versions in granite and bronze, 1934) and *Girl with Child* (stone, 1935, with later casts in bronze) – did not last for long and after 1935 he worked increasingly in a figurative style with classical overtones. However, during the Second World War, Makovský turned his attention instead to the design of machine tools and the full-scale plaster models of these are amongst the most striking exhibits of the Gottwaldov Art Gallery. During this time he was teaching at the School of Fine Arts at Zlin, near Gottwaldov, (1939-45) and after seven years teaching at the School of Higher Technical Studies at Brno, Makovský was from 1952 until his death Professor of Sculpture at the Academy in Prague.

191. Josef Wagner
Erratic Block, 1929, stone, 41 cm

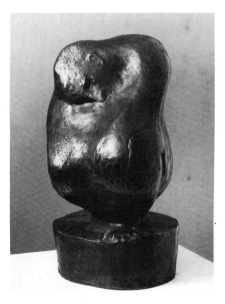

124

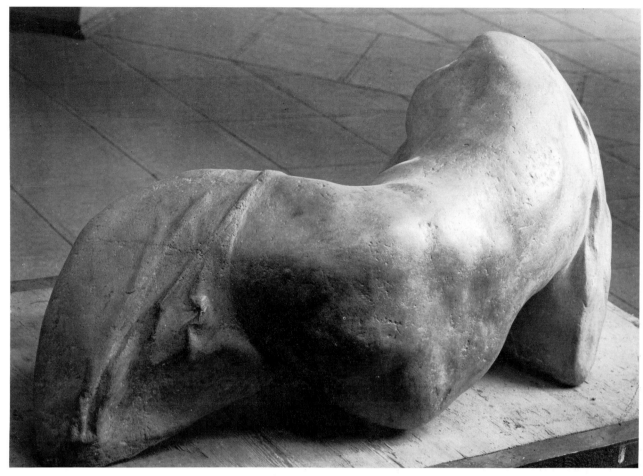

192. Josef Wagner
Lying torso, 1935, sandstone, 57.5 cm

Josef Wagner

Like so many of the earlier generations of Czech sculptors, Josef Wagner (1901-1957) learnt his trade, so to speak, as a stone cutter. As a young boy he began his training in the family workshop at Jaroměř, from his step-father before studying under Kocián at the School for Sculptors and Stone Masons at Hořice until 1921. After graduating, he entered the Academy in Prague and studied in the Sculpture School, first under Štursa and then, after Štursa's suicide, under Španiel, who also came from Jaroměř. Apart from attending Gutfreund's classes on sculpture for buildings (1926-27), he went on a number of study trips (to Paris, 1926; Italy, 1930; Italy and Greece 1932) and restored M.B. Braun's sculptures at Jaroměř and Kuks during the early 1930s. Wagner's earliest work is stylistically confused and not particularly distinguished, as he wavered between the clarity of the Objective Realist forms of Gutfreund (for example *Lilie*, plaster, 1928) and his natural leanings as a stone carver. Indeed the conflict between modelling and carving in his work was never satisfactorily resolved and his finest work was always carved, often direct. To this inner feeling for stone Wagner added a practical insight, and his concerns in the early 1930s are encapsulated in his *Sculptor*

(sandstone, 1932-34). However these are already apparent in the poignant *Erratic Boulder* (1929) and his *Study for Torso on a Pebble*, (signed and dated 1929, although the latter sculpture was not executed until 1934). His highly simplified torsos, carved in sandstone in the mid-1930s, grew out of both his experiences in Greece and Italy, and his work as a restorer of Braun's stone sculptures, although a more direct impact of Braun's forms is evident later in his reclining sandstone figure, *Clouds* (1938). Braun's reliefs were also behind the strange modelled relief entitled *The Skies* (bronze 1933). Throughout the 1930s Wagner remained a complex, poetic personality, and he succeeded in retaining this detachment and independence during the last decade of his life.

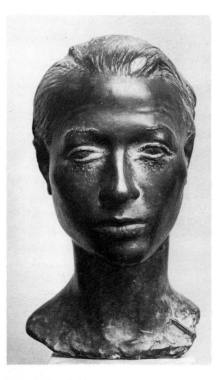

193. Karel Lidický
Portrait of Jarmila Blazliová, 1936, bronze, 36 cm, signed and dated

Karel Lidický

Also a stone carver by early training and inclination, Karel Lidický (1900-1976) did not arrive at the School for Sculptors and Stonemasons at Hořice until 1922, after the departure of Josef Wagner. Consequently, when he went on to the Academy in Prague, he missed being taught by Štursa and instead was a pupil only of Španiel, until 1931. However he did not seek inspiration outside Bohemia, preferring instead to draw upon Czech sources, above all Czech Baroque sculpture. Lidický's early *War Memorial* (stone, 1928) depicting a life-size wounded soldier in a heavy greatcoat sinking to the ground owes much to the example of Gutfreund and Objective Realism and demonstrates his mastery of the medium at the outset of his career. Subsequently, however, the posthumous influence of Štursa strengthened, though Lidický throughout the early 1930s maintained the integrity of his individual vision. There is a certain dichotomy, as with Wagner, between Lidický's style as a modeller and that as a carver and the continuing impact of Czech Baroque sculpture is at first concentrated in his carvings. This is demonstrated well in the stone carvings of the *Lost Son* (life-size 1936; reduced size 1937) reaching a climax in the harrowing stone figures *Dolorosa* (1940) and *Sorrow* (1943). Although most of the career of Karel Lidický falls outside the scope of this survey, the consistently high quality of his sculpture and the strength of his integrity shone through the black years of the Second World War and German Occupation like a beacon to provide a vital foundation on which the post-war generation could begin to rebuild.

194. Karel Lidický
Lost son, 1937, bronze, 15 cm.

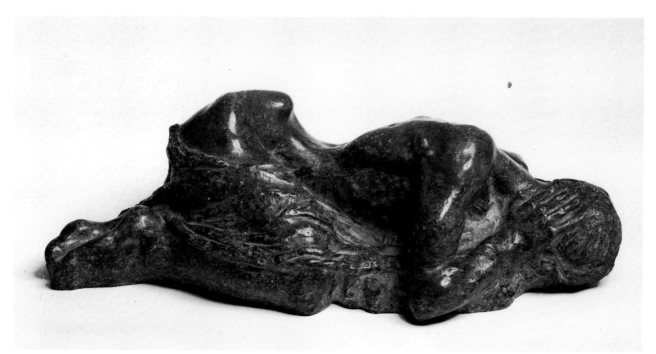

The author and the publishers wish to thank the National Gallery for supplying the illustrations in this book, and in particular the following photographers and agencies:
Tibor Honty, N6, Stenc, Josef Ehm, and Josef Sudek.